DISCOVER DRAWING SERIES

Draw Fashion Models!

Lee Hammond

NORTH LIGHT BOOKS
Cincinnati, Ohio

ABOUT THE AUTHOR

Polly "Lee" Hammond is an illustrator and art instructor from the Kansas City area. Although she has lived all over the country, and was raised in Lincoln, Nebraska, she calls Kansas City home.

She is now the owner of a new teaching studio, the Midwest School of Illustration and Fine Art. There she teaches "artists" of all ages. The school covers a variety of art techniques and mediums with the focus being on portraits and realism. It is located in Lenexa, Kansas, a suburb of Kansas City.

Lee has been an author for North Light Books since 1993. She is also a traveling seminar instructor, demonstrating and teaching various art techniques, including use of the Prismacolor line of art products.

She has three children, Shelly, LeAnne and Christopher, and one granddaughter, Taylor. They all reside in Overland Park, Kansas.

Draw Fashion Models! Copyright © 1999 by Lee Hammond. Manufactured in Hong Kong. All rights reserved. No part of this book may be reproduced in any form or by any electronic or mechanical means including information storage and retrieval systems without permission in writing from the publisher, except by a reviewer, who may quote brief passages in a review. Published by North Light Books, an imprint of F&W Publications, Inc., 4700 East Galbraith Road, Cincinnati, Ohio 45236. (800) 289-0963. First edition.

Other fine North Light Books are available from your local bookstore, art supply store or direct from the publisher.

08 07 06 05 9 8 7 6

Library of Congress Cataloging-in-Publication Data

Hammond, Lee.
 Draw fashion models! / by Lee Hammond.
 p. cm.—(Discover drawing series)
 Includes index.
 ISBN 0-89134-896-4 (alk. paper)
 1. Fashion drawing. I. Title. II. Series.
TT509.H334 1998
741.6'.72—dc21 98-20238
 CIP

Edited by Glenn L. Marcum
Production edited by Bob Beckstead
Designed by Mary Barnes Clark

DEDICATION

This book is dedicated to my three favorite girls. Shelly, LeAnne and Taylor. Although life has dealt us many obstacles to overcome, they keep me believing that all things are possible.

ACKNOWLEDGMENTS

Throughout my twenty years of teaching, I have had the pleasure of instructing hundreds of students. Each one has their own individual goals and desires concerning their art. Every agenda is important to me. My goal, as a mentor and instructor, is to see that every student reaches the level of success that they are striving for.

I remember back to my beginning, when I first decided to pursue art as my profession. I knew the style I wanted to create, but I had no sources to turn to for guidance. The schools I attended did not address this drawing technique, and I was left feeling empty and inadequate in my abilities. My style, the Hammond Blended Pencil Technique, is the result of many years of self-teaching. It was not easy; actually it was extremely frustrating.

I see students come to me now with much more skill and ability than I had way back when. Many believe that I was born being able to draw like this and don't believe the stories of how weak my drawing skills actually were. Trust me, I was not very good, and I still am not where I want to be.

I teach because my art and art techniques mean nothing to me unless I am sharing my secrets and showing someone else how to enjoy them too.

I teach a step-by-step method—the way I wish someone had taught me when I was young.

Please allow me to act as your personal artistic guide. Believe me when I say "You can do it!!!" I've witnessed my students' successes too many times to believe otherwise.

So, to all of you who like my technique and buy my books, I thank you. Thank you for allowing me this wonderful opportunity to enhance your lives through art. I also thank North Light Books, particularly my production editor, Bob Beckstead, and my new editor, Glenn Marcum, for remaining the vehicle for me to reach people with my words and illustrations. I am a very, very lucky person to be given this opportunity and will never take this gift for granted.

I will also never take for granted the friendships that have kept me going. Special heartfelt thanks to Laura Tiedt, my soul mate, and Lanny Arnet, my protector and best friend, who are both always, unconditionally, there for me.

CONTENTS

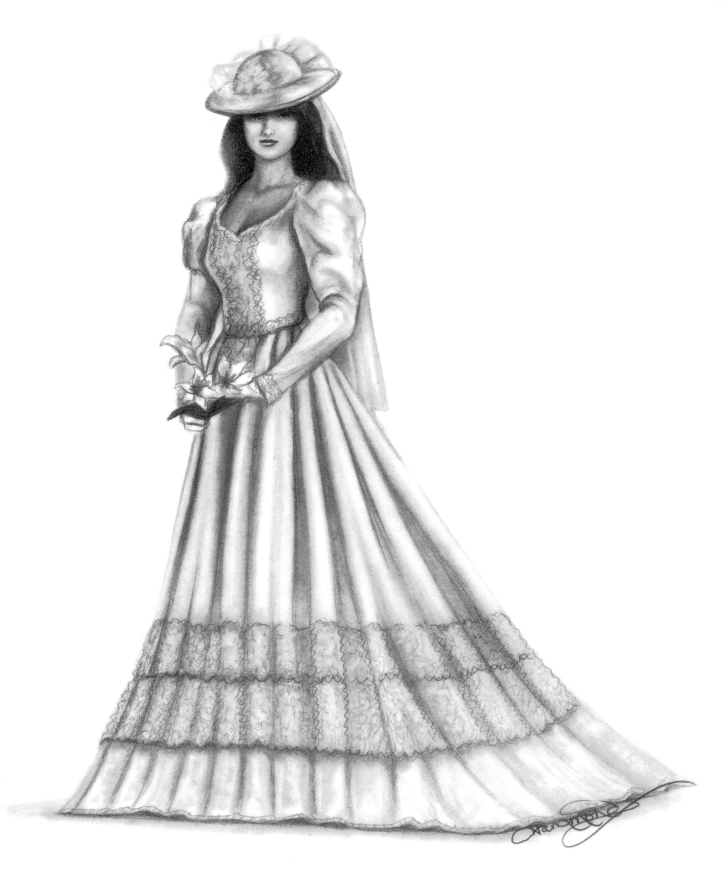

Portrait of Kayce

WHAT IS FASHION ILLUSTRATION?

When I first started to make a living with my art, my business card read "Illustrator," not Artist. Although I consider myself to be creative, and an artist, it was important to me to establish what I "did" as opposed to what I "was." There is a difference.

For pleasure and self-expression I create drawings and paintings that are considered good art and pleasing to look at. But, professionally, I illustrate. This means I describe something through my drawings. It is a pictorial that tells a story and tells you, the viewer, something about what you are looking at.

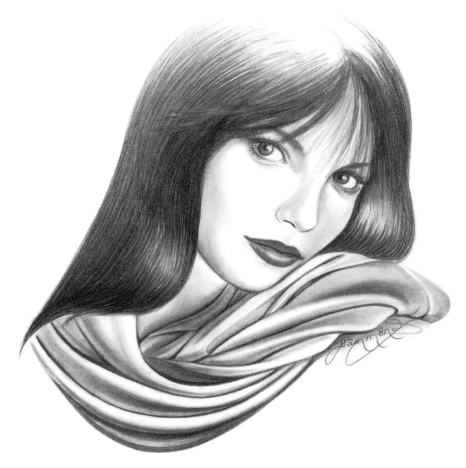

The Photograph

This photograph is much more than an ordinary snapshot of my friend's daughter, Kayce. It's a fashion photo clearly designed by the photographer to strike a mood and create an attitude.

The pose, expression and lighting have all been blended together into a piece of art. It captures the eye and evokes a feeling about what you are looking at.

Fashion photography, and fashion illustration, are art forms in themselves. Their creation is a complicated science that, when done properly, appears simple. It sends out a message, loud and clear, to the viewer through its images.

So what is fashion illustration? It is much more that a drawing or photograph of an article of clothing. Fashion illustration is meant to not only represent the garment, but is designed to give you a *feel* for it, too. It is meant to *sell* you an attitude about it.

Anyone can take a picture but it takes an artist to create a certain mood with their pictures. It takes an illustrator to render not only a drawing, but a feeling, with their art.

Portrait of Kayce

The pose in this photo illustrates a mood of calm elegance. The quiet expression and pose of the hand gives it a graceful, feminine appearance. It creates a mood of peacefulness.

The lighting helps describe the shape of the body through subtle lights and darks.

Selling a "Look"

I created this drawing using crisp lines and extreme contrasts to illustrate the outfit's shape. It gives the drawing a striking, eye catching appearance.

The tilt of the hat covers the model's face, forcing the viewer to examine the clothing instead. This is what fashion illustration is all about. It's designed to sell you a "look," by giving you a feeling for what you are looking at.

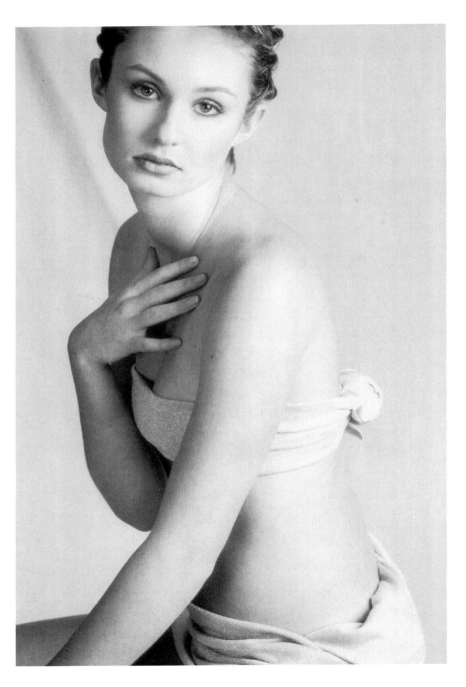

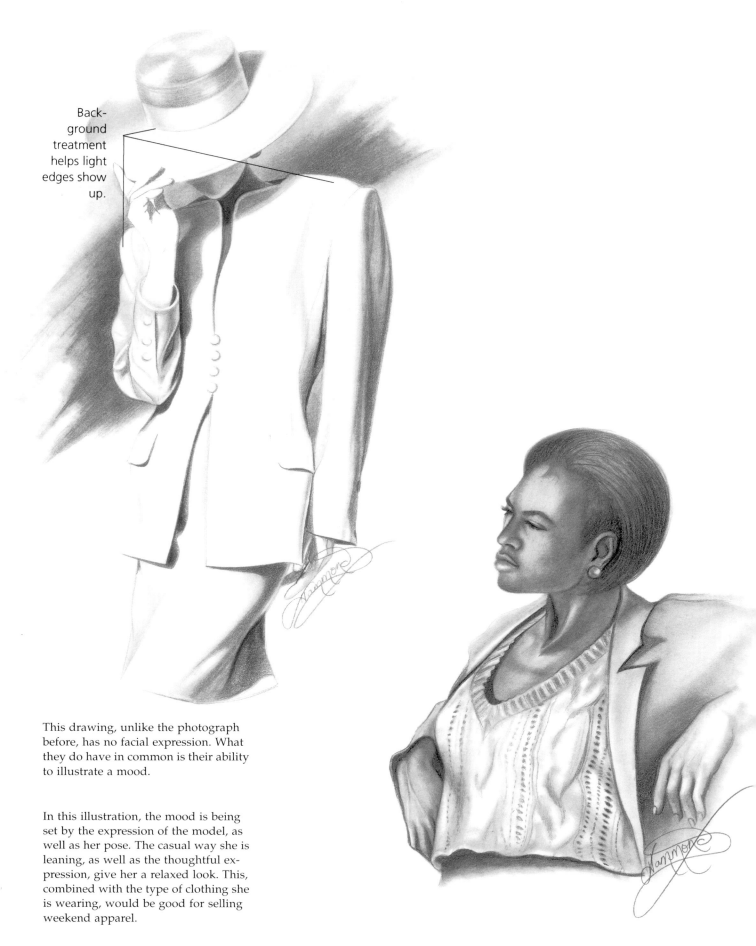

Back-
ground
treatment
helps light
edges show
up.

This drawing, unlike the photograph
before, has no facial expression. What
they do have in common is their ability
to illustrate a mood.

In this illustration, the mood is being
set by the expression of the model, as
well as her pose. The casual way she is
leaning, as well as the thoughtful ex-
pression, give her a relaxed look. This,
combined with the type of clothing she
is wearing, would be good for selling
weekend apparel.

STANCE

Often it's more the pose of the body, as opposed to the look of the face, that catches your eye. In this fashion photo, it's the body stance that helps create the mood.

This is called a *pelvic-thrust* stance. By projecting the head and hips forward it creates a casual, relaxed appearance. Notice how it affects the way the shirt drapes off the body. This is one of the most common fashion stances.

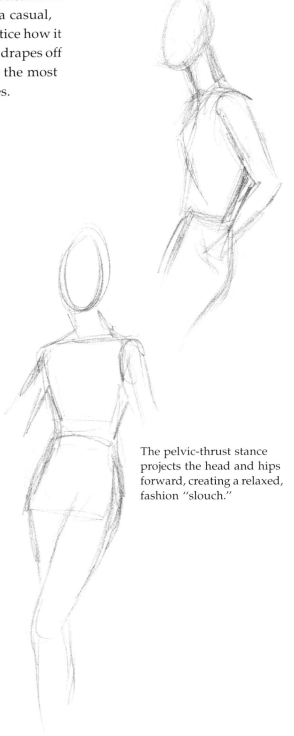

The pelvic-thrust stance projects the head and hips forward, creating a relaxed, fashion "slouch."

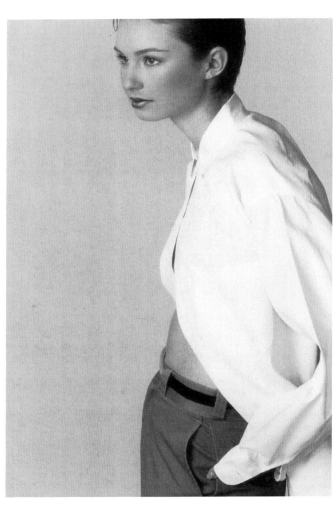

The pelvic-thrust stance: one of the most common fashion poses.

LIGHTING

In these examples, both the face and body pose are important for creating the mood. The contrast created by the light source is extremely provocative. Notice how both illustrations, although different, have a similar feeling to them.

Both drawings have an extreme dark side opposite a bright one.

The stark white seems to illuminate the subjects, giving them a mysterious quality.

The illustration of the woman is selling a "look." It's designed to make you look more at the hair and overall style of her appearance.

The man, on the other hand, is also selling style but is designed to sell the clothing instead. The lighting conveys a mood that says evening wear. If it were drawn using traditional lighting it would represent business attire.

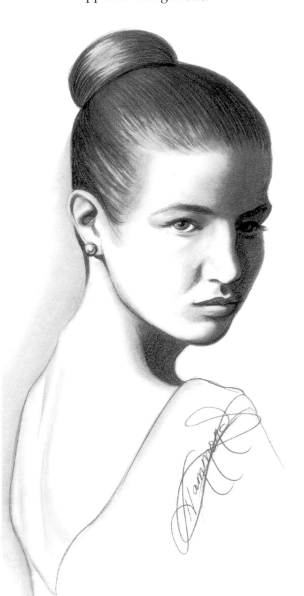

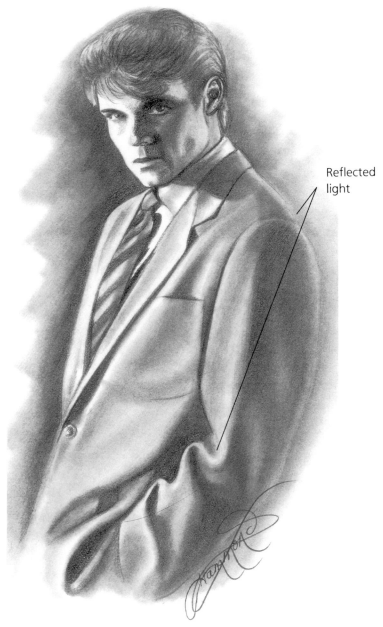

Reflected light

The extreme lighting creates a mysterious mood for this illustration. It's designed to sell a "style" and a "look."

This also uses extreme lighting to create an evening look. The focus of this drawing is more on the clothing than on the face. Notice the pelvic-thrust stance, which creates the relaxed slouch.

CHAPTER TWO
MATERIALS

You cannot do quality artwork with inadequate art materials. My blended pencil technique requires the right tools to create the look. Do not scrimp in this department or your artwork will suffer. I have seen many of my students blame themselves for being untalented when it was their supplies keeping them from doing a good job. The following list will help you be a better artist.

Smooth Bristol Boards or Sheets—Two-Ply or Heavier
This paper is very smooth (plate finish) and can withstand the rubbing associated with the technique I'll be showing you.

5mm Mechanical Pencil With 2B Lead
The brand of pencil you buy is not important; however, they all come with HB lead—you'll need to replace it with a 2B lead.

Blending Tortillions
These are spiral-wound cones of paper. They are not the same as the harder, pencil-shaped stumps that are pointed at both ends. These are better suited for the blended pencil technique. Buy both large and small.

Kneaded Eraser
These erasers resemble modeling clay and are essential to blended pencil drawing. They gently "lift" highlights without ruining the surface of the paper.

Typewriter Eraser With a Brush on the End
These pencil-type erasers are handy due to the pointed tip, which can be sharpened. They are good for cleaning up edges and erasing stubborn marks, but their abrasive nature can rough up your paper.

A 5mm mechanical pencil and blending tortillions.

Horsehair Drafting Brush

These wonderful brushes will keep you from ruining your work by brushing away erasings with your hand and smearing your pencil work. They will also keep you from spitting on your work by blowing the erasings away.

Pink Pearl or Vinyl Eraser

These erasers are meant for erasing large areas and lines. They are soft and nonabrasive and will not damage your paper.

Workable Spray Fixative

This is used to seal and protect you finished artwork. It's also used to "fix" an area of your drawing so it can be darkened by building up layers of tone. "Workable" means you can still draw on an area after it has been sprayed.

Drawing Board

It's important to tilt your work toward you as you draw to prevent distortion that occurs when working flat. A board with a clip to secure your paper and reference photo will work best.

Ruler

This is used for graphing and measuring.

Acetate Report Covers

These are used for making graphed overlays to place over your photo references. They help you grid what you are drawing for accuracy.

Magazines

These are a valuable source of practice material. Collect magazine pictures and categorize them into files for quick reference.

A typewriter eraser and Pink Pearl vinyl eraser.

A horsehair drafting brush.

CHAPTER THREE
BASIC SHAPES

Everything we see is made up of interlocking shapes. It is very important to see these shapes in order to draw something accurately. The following are some of the most commonly used basic shapes.

The Sphere

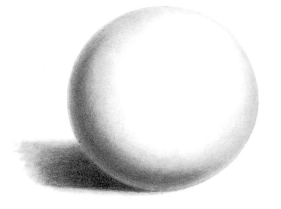

The foundation for anything with a rounded shape.

The Cylinder

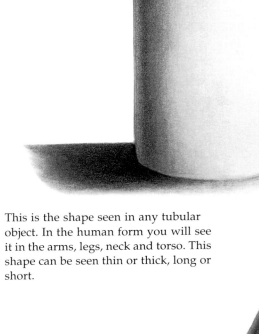

This is the shape seen in any tubular object. In the human form you will see it in the arms, legs, neck and torso. This shape can be seen thin or thick, long or short.

The Egg

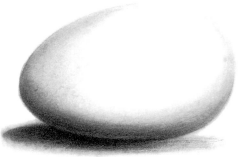

This can be seen in the shape of the human head (not to mention a football).

The Cone

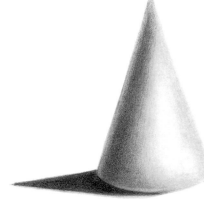

Although this shape is less common in the human form, it can be seen in clothing. For an example, turn back to the illustration on page 9. If you look closely at the sleeve on the right you will see the cone shapes.

BODY SHAPES

To successfully draw fashion figures using my blended pencil technique, there are two important elements that must be mastered. The first one is *shape*, and the other is *blending*.

Let's look at some of the basic shapes seen in the human form. I am not talking about the shapes of the inner structure, like the skeleton and muscles, but the simple, basic shapes that make up everything.

This grouping may seem like a strange collection of shapes, but you will see how they all fit together to represent the shape of the body.

These shapes are modified versions of those on the previous page. Viewed like this you can see how they resemble some of the body shapes. Take note of how the shading makes them appear three-dimensional.

Together these shapes create the form of a fashion figure.

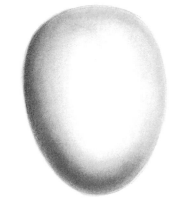

This oval or egg shape can be seen in the shape of the human head.

This rounded-off triangular shape can be seen in the shape of the upper body or chest area.

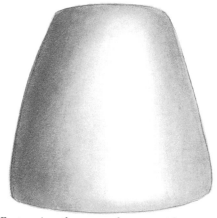

By turning the same shape upside down, you now have the shape of the lower body, or hip area.

This long cylindrical shape, or tube, can be seen in the shapes of the arms and legs.

This short cylindrical shape can be seen in the shape of the neck and waist.

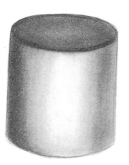

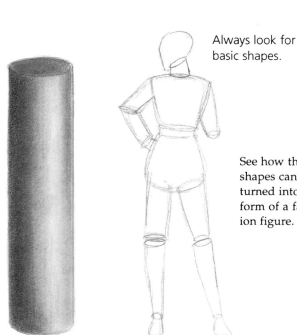

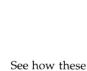

Always look for basic shapes.

See how these shapes can be turned into the form of a fashion figure.

PROPORTION

To draw the body correctly it's very important to have the shapes drawn in proper proportion. To do this you can use this figure scale as a reference.

This is called a *head scale*. It divides the figure into equal increments, all the size of the head. Most adults are between seven and eight heads tall.

Pay particular attention to where the arms fall against the body. It's common for students to draw the arms too short. Always remember that the elbows are at the waist and the fingertips touch mid-thigh. Study the head scale and memorize where the body parts fall. Use this as your guide when drawing figures.

In fashion it is common to alter the body shape to make it more flattering for the clothing. To make the figure appear taller, more length is given to the legs, from mid-thigh down, to make it nine heads tall, as opposed to the usual seven or eight.

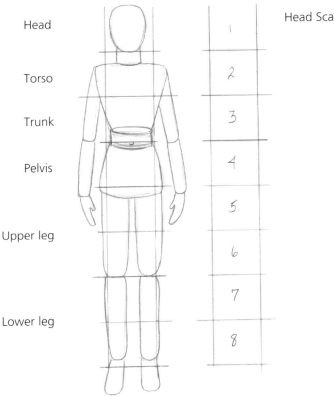

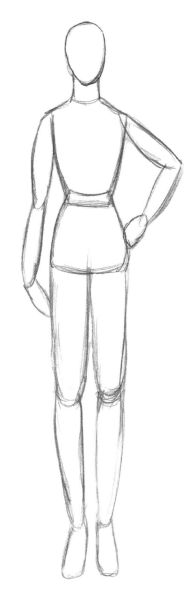

The human body is divided into seven or eight head measurements. The eight-head scale shows you the proper size and placement of the body shapes.

1. The head size is the comparison for all other body areas.
2. The second "head" measurement takes you down to the chest, dividing the chest and upper arm.
3. The third measurement takes you to the stomach region or trunk. This line will fall around the navel and cut across the arm at the elbow.
4. The fourth measurement takes you to the lower pelvic region where the legs meet the body. It also lines up with the wrist area of the arm.
5. The fifth measurement falls in the middle of the upper leg, just below the thigh. Notice how the fingertips almost reach this point.
6. The sixth head measurement takes you down to the knee area.
7. The seventh head measurement falls along the shins.
8. The last measurement brings you to just below the ankle where the foot hits the floor.

In fashion drawing it is common to lengthen the figure into a nine-head scale to make it appear taller and thinner. This is done by adding some length to the legs from mid-thigh down.

BODY CHARACTERISTICS

The Skeleton

The skeletal system is the foundation or framework for the shape of the human body. While you are drawing the form, remember the shape of the bones and muscles that make up the human body.

The Female and Male Body

There are many differences between the male and female body.

The male body is usually larger with a thicker, more angular, boxy appearance.

The female body is more curved and tapered—characteristics which are usually exaggerated in fashion illustration to give the models more visual impact to highlight and accentuate the clothing they are wearing.

Modifying the Figure

These two illustrations show you how modifying the figure for fashion works. The first drawing shows the body drawn in its proper, accurate proportions. In fashion, however, we must take the emphasis off the person and draw the eye and attention to the clothing. You must make the outfit appear as fashionable and attractive as possible, because that is what you are selling to the viewer.

I made the head a little smaller so the shoulders now have more impact. I adjusted the waist to give the dress more shape and curve. I drew the hands a little smaller to make them less noticeable. The overall look is more sleek, making the dress seem more fashionable.

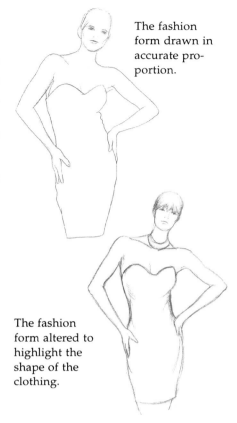

The fashion form drawn in accurate proportion.

The fashion form altered to highlight the shape of the clothing.

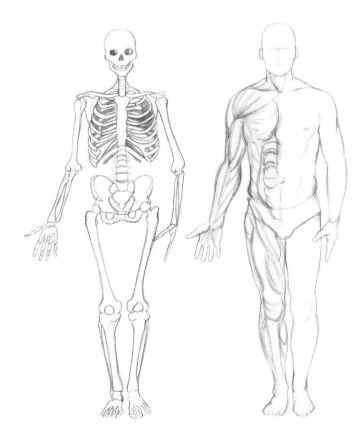

◄ It is the skeleton and the muscle structure that creates the framework for the human body. Always remember this as you draw the human form. It is the muscle and flesh surrounding our bones that give us our fullness.

The female figure ► is more slender and tapered than the male. This figure is exaggerated in fashion illustration.

The male figure is more angular and boxy.

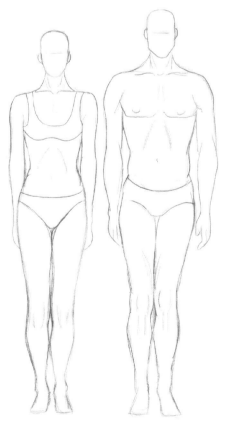

REAL VS. FASHION

When working from photo references, it's important to remember that the photograph is merely a guide. After all, if you were to make the figure exactly like the photo, there would be no need for the illustration. Your goal is to use the photo as a way of creating art.

You, as the artist, should take from the photograph the things you like and need and eliminate the unnecessary.

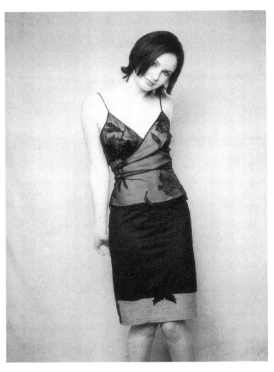

◄ This is a nice fashion photograph. It does a good job of describing the outfit for the viewer.

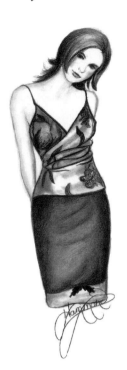

In my illustration I made some changes. ► I accented the shape and curve of the dress to make it more shapely, giving it a smoother line. I made sure I maintained the color and pattern of the dress in my drawing.

Since this illustration is meant to highlight the outfit, I didn't try to create a portrait of the model. I made the head a little smaller and lengthened the hair to accent the shoulder line. I chose to eliminate the legs altogether to give the form a more streamlined effect, and allowed my signature to carry the line down.

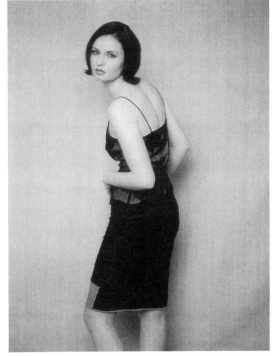

◄ This photo shows more about the body pose than it does the outfit. I like the pose and the gentle curves of the body.

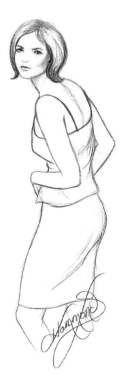

This time I decided to keep the illustration in simple line form. This way I could concentrate on the body shape, although it still tells the viewer what type of outfit it is, leaving the details up to the imagination.

PRACTICE POSES

It is important to practice drawing the fashion figure in as many poses as possible. To concentrate on the form and proportions, practice drawing in line only as the illustrations here show. By drawing in line you can focus on the basic shapes and the way the clothing hangs on the form.

Look for the basic shapes in these figures. Can you see the egg shape in the heads, modified triangles in the chests and cylinders in the arms?

Watch for the tilt of the body (pelvic thrust) and the angles, especially in the shoulders and waistline. These are the things that can be exaggerated to help illustrate the garments in their most appealing light.

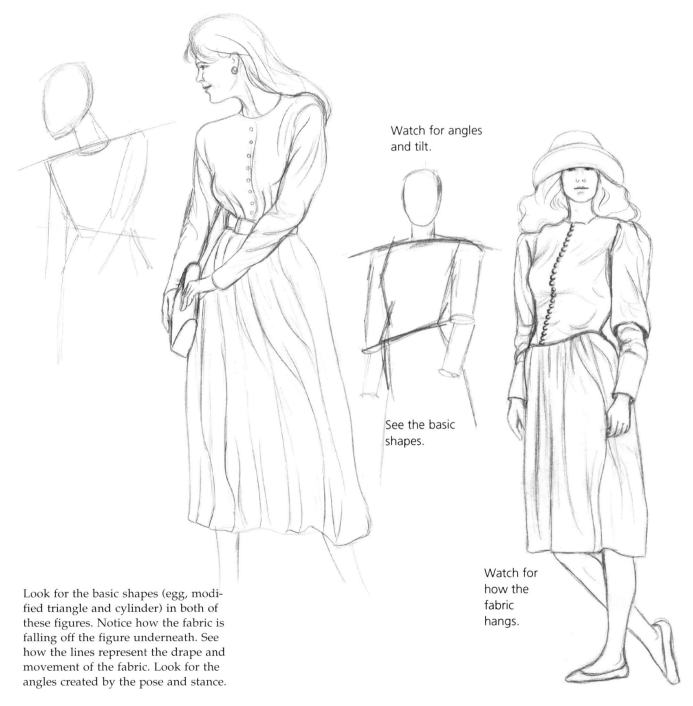

Watch for angles and tilt.

See the basic shapes.

Watch for how the fabric hangs.

Look for the basic shapes (egg, modified triangle and cylinder) in both of these figures. Notice how the fabric is falling off the figure underneath. See how the lines represent the drape and movement of the fabric. Look for the angles created by the pose and stance.

BLENDING AND SHADING

A smooth blend from dark to light is the key element in my blended drawing style. While blending may look simple, especially with these beginning exercises, it requires a lot of practice to make it appear smooth and gradual.

This is where I start all of my students. This is where you will become familiar not only with the the technique but also with your tools. It is the tortillion that creates this style of drawing. Practice drawing a value scale such as the smoothly blended one below using your pencil and tortillions.

Be sure to build the dark area gradually, applying your pencil lines evenly, up and down in the same direction. Lighten your touch as you progress to the right, lightening the tones as you go. Try to make the fade as gradual as possible, without any separation in tone, or choppiness, until the tone fades into the white of the paper.

To blend, use one of your tortillions. Use it the same way you did the pencil, going over your drawing to blend the tones together. Use the tortillion at an angle so you do not push in the point. Apply it in the same direction you applied the pencil lines, softening your touch until the tone fades into nothing.

You should not be able to see where one tone ends and another begins. If choppiness does occur there are tricks to fix it. First of all, squint your eyes while looking at your drawing. This helps blur your vision and allows you to see the contrasts in tone more easily. The dark areas will appear darker and the light areas will appear lighter. This makes any irregularities stand out. Should you see any unwanted dark spots in the drawing, take a

piece of your kneaded eraser and roll it between your thumb and forefinger to create a point. Gently lift the dark spot out with the eraser by stroking it lightly. Never dab at it. I call this "drawing in reverse," since it is not just erasing but is a controlled technique. Should you see any little light areas that shouldn't be there, lightly fill them in with your pencil.

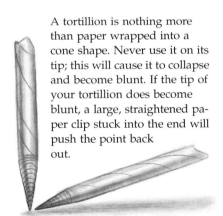

A tortillion is nothing more than paper wrapped into a cone shape. Never use it on its tip; this will cause it to collapse and become blunt. If the tip of your tortillion does become blunt, a large, straightened paper clip stuck into the end will push the point back out.

This is the proper angle for using a tortillion.

Since it is the blending that creates an object's shape, it's important to learn how to blend in a curve. Once you have mastered the blending scale, try blending in an arch or circular shape, as shown on page 21.

A smoothly blended value scale from dark to light.

An incorrectly drawn value scale, Because of the scribbled application of pencil lines in this scale, it's impossible to blend it out evenly.

THE FIVE ELEMENTS OF SHADING

To apply blending and shading to your drawing, you must first understand what that shading represents. Shading represents the tones of the object and how the object's color is being affected by light and shadows. These tones are broken down into five ele-

Identify the Five Elements

Look at the sphere and the cylinder and identify all the elements of shading.

1. Cast Shadow. This will always be the darkest dark on your drawing. It is caused by the object itself blocking the light with its shape. It is always opposite the light source.

2. Shadow Edge. This is where the object curves away from the light. This is the area that shows the most roundness.

3. Halftone. This is the neutral area; neither in bright light or in shadow. It is halfway.

4. Reflected Light. This is always found along the edge of an object. It's caused by the light coming around from behind and bouncing up from surrounding surfaces. It tells you there is a back side to the object. It is most noticeable in the shadow area where it separates the cast shadow from the shadow edge. Without reflected light, all of the dark areas would appear to run together, making the object look flat.

5. Full Light Area. This is where the light is the strongest. It tells you where the light is coming from, giving you direction.

ments which are best illustrated on the sphere. It is important to memorize all five elements and the roles they play.

The five elements of shading are the most important lessons I teach. Without shading, nothing looks realistic. Of all the projects in this book, this is the one I recommend the most—and do not advance until you are proficient and comfortable with your results.

Observe how the five elements apply to both the sphere and the cylinder. They will apply to any rounded object. My experience with teaching has proven that the two elements students most often leave out, and which I believe to be the most important, are (1) reflected light and (2) the cast shadow. Ironically, these are the two most dramatic elements in fashion illustration.

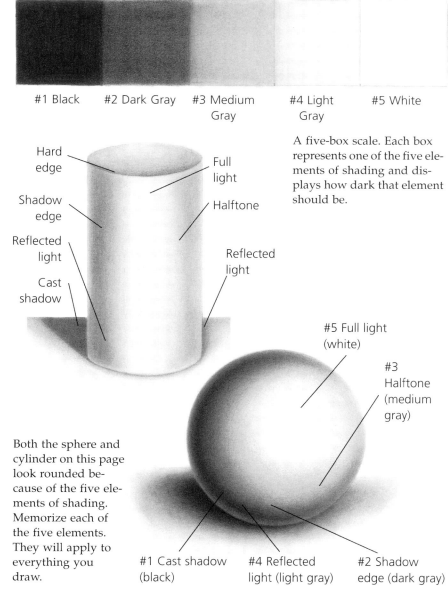

#1 Black #2 Dark Gray #3 Medium Gray #4 Light Gray #5 White

A five-box scale. Each box represents one of the five elements of shading and displays how dark that element should be.

Hard edge

Full light

Shadow edge

Halftone

Reflected light

Reflected light

Cast shadow

Both the sphere and cylinder on this page look rounded because of the five elements of shading. Memorize each of the five elements. They will apply to everything you draw.

#5 Full light (white)

#3 Halftone (medium gray)

#1 Cast shadow (black) #4 Reflected light (light gray) #2 Shadow edge (dark gray)

BLENDING EXERCISES

Now it's time to put all of this information to use. Let's begin with a simple sphere. We'll start with an empty outline of a circle.

The Sphere

Step 1

Use a stencil or template to trace a perfect circle. The light will be coming from the top right. This means the cast shadow will be under the left side. Be sure to keep a crisp edge along the side of the circle when applying the shadow or the circle won't look like a circle anymore.

Begin to place some tone to represent the shadow edge. Apply your pencil lines with the contour of the circle. Be sure not to take the tone clear to the edge—we must have some room for the reflected light. Reflected light is not white, but is a halftone.

Step 2

Continue to apply tone to the shadow edge, lightening it as it approaches the light source.

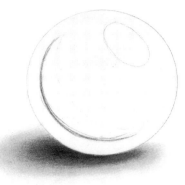

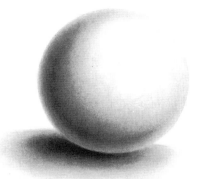

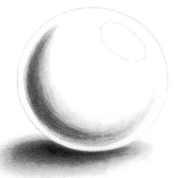

Step 3

With your tortillion, blend the tones out until they look very smooth. Apply the tortillion the same way you did the pencil lines—with the contour of the ball. Now the empty circle has dimension and form. It is no longer flat, but appears to have three dimensions. To further enhance the realism, be sure to lighten any outline that may be around the edge. Allow shading to create an edge instead. Anything with hard outlines will appear cartoonlike.

The Cylinder

Use the same process for completing the cylinder. Use a ruler to keep the sides straight. Blend up and down with the tortillion. Let it fade gradually, keeping the value scale in mind as you work.

Begin with a pencil sketch.

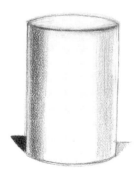

Apply pencil lines up and down.

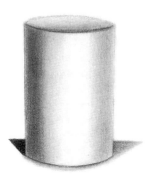

Blend up and down. Fade into the light area.

PUTTING IT ALL TOGETHER

So, how does all this blending and shading apply to fashion illustration? These two examples will show you.

Taking the drawing further than a line drawing and rendering the tones of the fabric and form give the illustration more realism. Instead of the flat impression line drawing provides, these drawings have dimension. The five elements of shading work together to provide realism and a better representation to the viewer of what the garment really looks like.

These drawings are similar in style, yet placing some shading behind one of them changes the mood. One appears day-oriented while the other portrays evening.

Artistically, the tone behind the drawing helps accentuate the edges of the fabric (reflected light). This helps prevent outlining, which could make the drawing appear cartoonlike. Notice how the edges of the coat without background shading have been created with blended tone, not hard outlines.

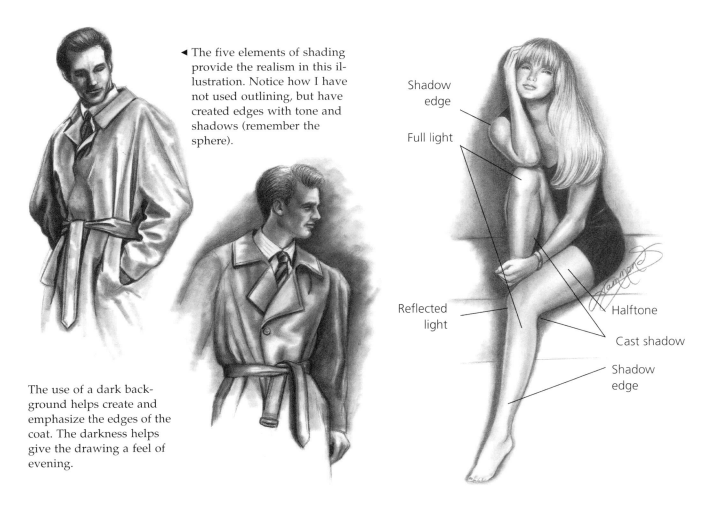

◄ The five elements of shading provide the realism in this illustration. Notice how I have not used outlining, but have created edges with tone and shadows (remember the sphere).

Shadow edge

Full light

Reflected light

Halftone

Cast shadow

Shadow edge

The use of a dark background helps create and emphasize the edges of the coat. The darkness helps give the drawing a feel of evening.

The five elements of shading can easily be seen in this body. Look for the basic shapes, predominantly the cylinder, in the arms and legs. Their roundness is created by the reflected light. Once again I used shading behind the figure so the reflected light would show up.

▲ Look for the five elements of shading in this drawing. Without them this figure would not have the roundness and softness that it portrays. The use of background, once more, helps to accentuate the reflected light.

DRAWING THE FIVE BASIC FABRIC FOLDS

Just as there are five elements of shading, there are five basic fabric folds. Each of these must be recognized, studied and remembered to draw clothing convincingly.

Just as the human form has basic underlying shapes to look for, clothing, too, must be seen as shapes. The two basic shapes most commonly seen in fabric are the cylinder and the cone. If you can accurately apply the five elements of shading to these two shapes you will be able to draw clothing with a realistic look.

Let us now begin to understand and study the five folds that are seen in fabric. If these can be memorized and recognized when studying your reference pictures, drawing clothing will not be an obstacle. However, without the proper practice and understanding of how these folds affect the clothing, your figure drawing will look unrealistic. As I said before, it is the clothing on the figure that affects its overall look the most.

Practice drawing a cylinder using the five elements of shading. See how the blending and shading create the look of roundness.

This cone is also seen in fabric shapes.

Overlapping creates a hard edge.

A gentle unrolling creates a soft edge.

If we were to unroll a cylinder, we would have a shape similar to that found in fabric. See how the crease on the left of the raised surface is darker? That crisp edge is created when two surfaces overlap one another. It's called a *hard* edge.

Can you see how the edge on the right of the raised surface is lighter and smoother? That is called a *soft* edge. It represents a gradual curve. The fabric here is not creased but is gently unrolling.

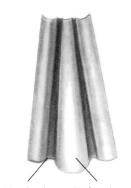

Hard edge Soft edge

Hard edges are evident in this illustration. Can you see how these shapes are starting to look like a section of curtain or a pleated skirt? Look for the cone shape. You can now see how important these two shapes (cone and cylinder) are to rendering fabric.

THE COLUMN FOLD

The column fold is the most common fabric fold. It is created when fabric is suspended by one point. This causes the fabric to roll and crease into the cone shapes we practiced before. Look at the way these towels hang from the hooks. Can you see the cone shapes that have formed? Look for the five elements of shading which give them the rounded look. The combination of shadow edges and reflected light makes these drawings look realistic. When drawing patterned fabric (the striped towel), the pattern must follow the folds. Also, watch for hard and soft edges in rounded areas and overlapping surfaces.

The second drawing demonstrates another type of column fold. This time we have a length of fabric connected to a surface. Where the fabric hangs, a column fold is created. Look for the familiar cone shape and you'll find a column fold.

In the third example, the fabric creates tubular columns that resemble cylinders. Remember the blending exercises and you will see them here.

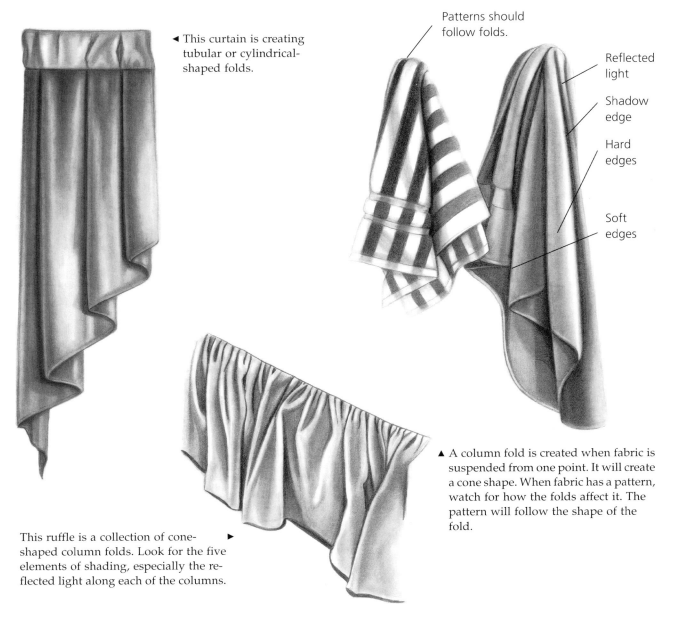

◄ This curtain is creating tubular or cylindrical-shaped folds.

Patterns should follow folds.

Reflected light

Shadow edge

Hard edges

Soft edges

This ruffle is a collection of cone-shaped column folds. Look for the five elements of shading, especially the reflected light along each of the columns. ▶

▲ A column fold is created when fabric is suspended from one point. It will create a cone shape. When fabric has a pattern, watch for how the folds affect it. The pattern will follow the shape of the fold.

COLUMN FOLD STEP BY STEP

Let's practice a column-fold exercise. Please remember the sphere and cylinder exercises from the previous chapter. The five elements of shading must be used to draw them correctly.

Start with a line drawing. Watch for how the shapes are created by the way the fabric is being suspended from the hook. Watch for how the stripe is going in and out of the columns. ▶

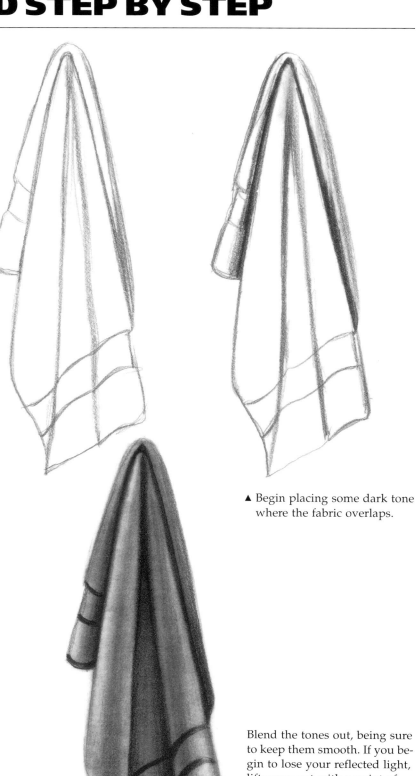

▲ Begin placing some dark tone where the fabric overlaps.

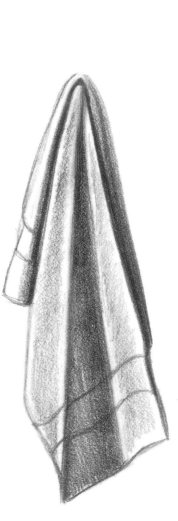

Place the shadow edges. Remember the cylinder exercise. Refer back to it if necessary. Watch for the edges of reflected light.

Blend the tones out, being sure to keep them smooth. If you begin to lose your reflected light, lift some out with a point of your kneaded eraser.

THE INERT FOLD

The second fold type is often found at the bottom of a column fold. This is an inert fold. It can be found where the fabric hits a surface and is no longer being supported. It is *inactive* and is lying motionless. An inert fold occurs on the bottom of a floor-length dress, such as a wedding gown, or when someone is sitting and their coat rests on the chair. It's the least common of the folds.

An inert, or inactive, fold occurs when fabric is lying on a surface and is no longer being supported. It's not as common as the other folds.

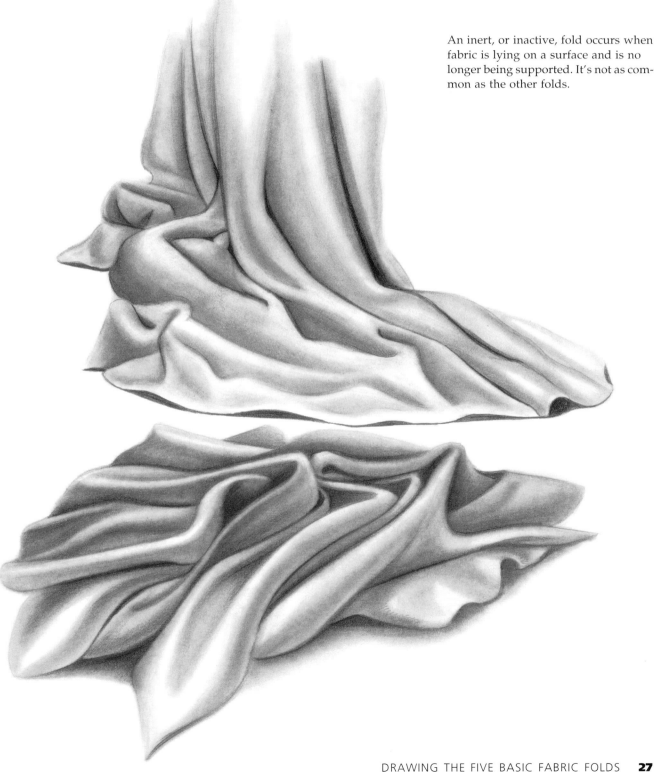

THE COIL FOLD

The third fold is the spiral or coil fold. It is always found when the fabric wraps around a cylindrical form such as the arm, leg or torso. This important fold shows the movement of the form underneath. For instance, when you move your arm, the fabric of your shirt or sweater will stress along with it. Showing these stresses in the fabric by the creases that are formed makes your drawing look real and convincing. Clothing drawn without these characteristics looks flat and boring.

Look how the fabric wraps around the arms and the leg in these examples. You can see the movement of the figure underneath—especially in the pant leg. The creases help describe the shape of the form.

The fabric of this dress looks bunched up because of the many creases. You can tell it's tight-fitting from the way it shows the contours of the body underneath.

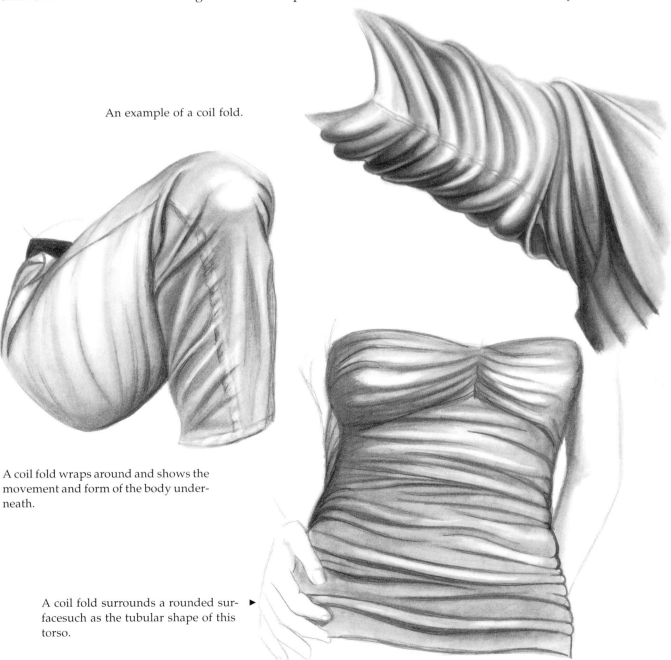

An example of a coil fold.

A coil fold wraps around and shows the movement and form of the body underneath.

A coil fold surrounds a rounded surfacesuch as the tubular shape of this torso. ▶

THE DRAPE FOLD

The drape fold is found where fabric is suspended between two points. Look at the fabric draped from shoulder to shoulder in this example; it creates a U shape. A drape fold can be found in scarves, shawls, cowl-neck sweaters; anywhere you have two points of suspension. You can see this dress also has coil folds around the arms.

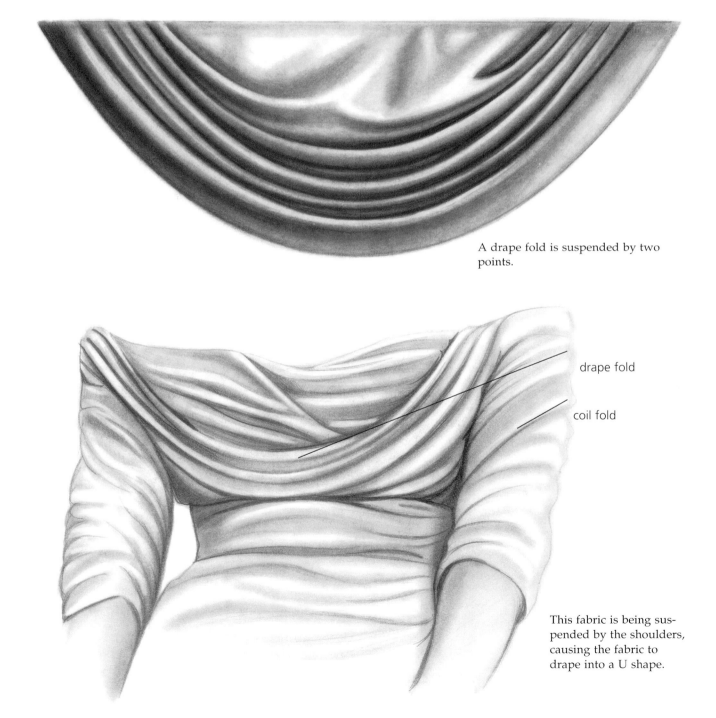

A drape fold is suspended by two points.

drape fold

coil fold

This fabric is being suspended by the shoulders, causing the fabric to drape into a U shape.

THE INTERLOCKING FOLD

The interlocking fold can be the most difficult to see as it may be the result of one fold or a combination of the other four folds.

Look closely at the scarf illustration. Although this is a coil fold, created by the way it wraps around the tubular shape of the neck, it's also an interlocking fold. This is due to the way each of the fold layers sit inside one another. One fold comes out of the next.

This example shows how an interlocking fold can be seen with a drape fold. Can you see how the two work together?

While this example may look like a series of column folds (which it is), it's also another example of an interlocking fold. Can you see how one fold nestles inside another, especially where the fabric falls over the arm?

A close look at this sleeve will reveal the beginning of a column fold hanging from the shoulder. However, because of the bend of the elbow, it becomes an interlocking fold instead.

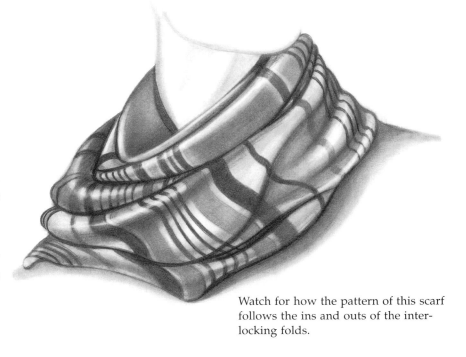

Watch for how the pattern of this scarf follows the ins and outs of the interlocking folds.

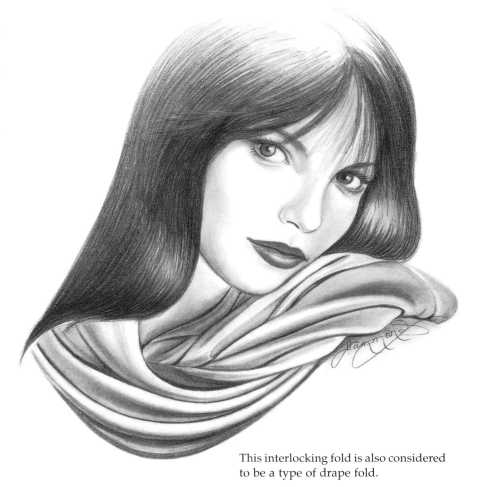

This interlocking fold is also considered to be a type of drape fold.

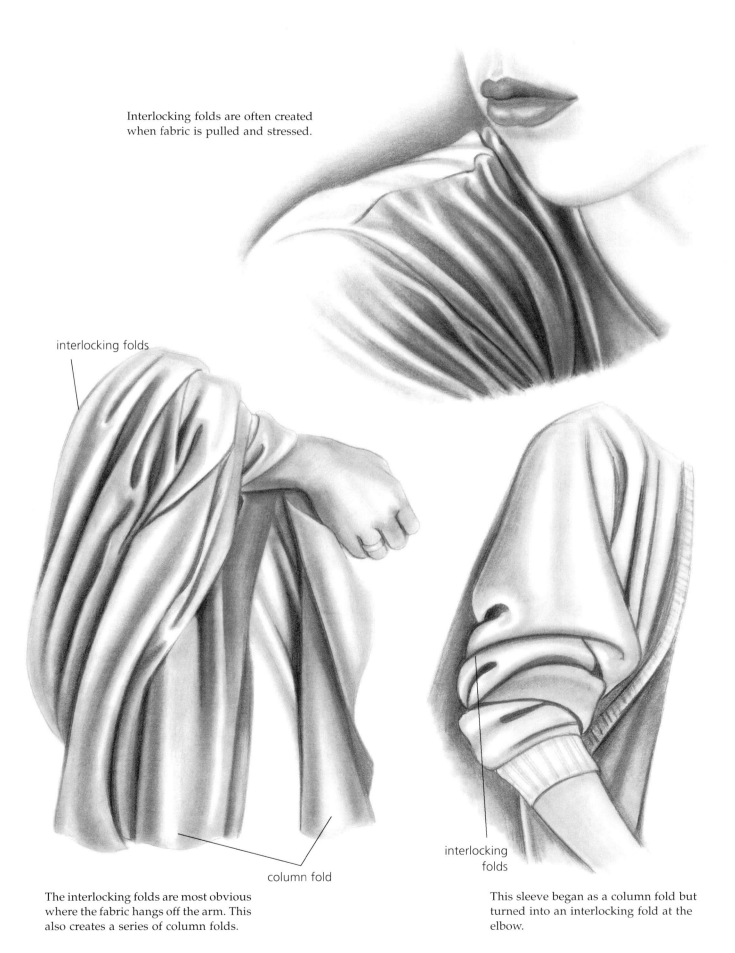

Interlocking folds are often created when fabric is pulled and stressed.

interlocking folds

column fold

The interlocking folds are most obvious where the fabric hangs off the arm. This also creates a series of column folds.

interlocking folds

This sleeve began as a column fold but turned into an interlocking fold at the elbow.

MULTIFOLD COMBINATIONS

We have seen how folds work together and how one garment can contain a combination of folds. Study each of the following illustrations and answer these questions for yourself.

1. How many folds can I identify in this garment?

2. What basic shapes make up this drawing (in both the figure and the fold)?

3. Where are the five elements of shading, particularly the cast shadows and reflected light?

4. Are there any patterns that I must pay attention to?

Sweater

This sweater also combines three folds. The coil fold around the arms is most obvious and the neckline hangs in a drape fold where the fabric is suspended by two points.

Coat

This coat has many folds but the most obvious is the drape fold. Look closely and you will see some interlocking folds combined with it. Move down the length of the sleeve and you will find a coil fold around the arm.

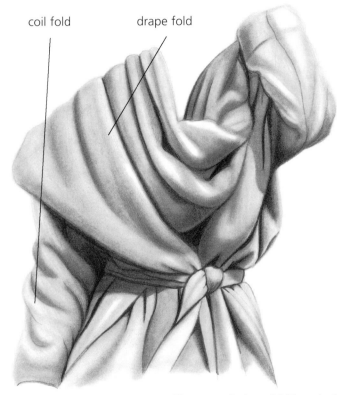

coil fold drape fold

The most obvious fold here is the drape fold.

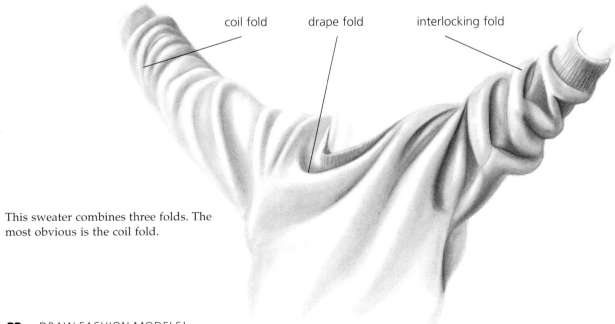

coil fold drape fold interlocking fold

This sweater combines three folds. The most obvious is the coil fold.

Coat and Scarf

What folds can you see in this outfit? Let me help you. Since coil folds wrap around something cylindrical, look at the sleeve. Drape folds are found when fabric is suspended between two points, so look at the scarf. Look at the shoulders to see column folds created by fabric falling from one point.

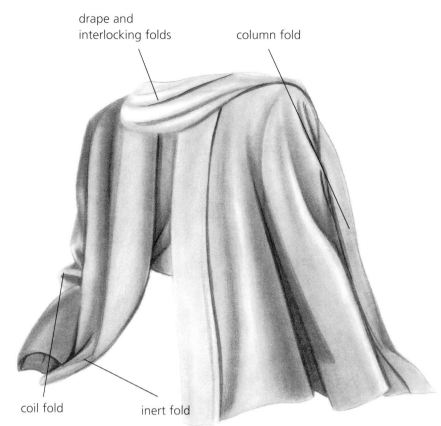

drape and interlocking folds

column fold

coil fold

inert fold

This garment contains all five folds.

Jacket and Scarf

Inert folds occur when fabric rests on a surface and is no longer suspended as in the jacket above the wrist. Interlocking folds can be seen where one fold nestles inside another, so you need to look everywhere!

The illustration of the sleeve is a good example of coil and interlocking folds working together.

Study this drawing of the jacket and scarf. You will see all five folds working in this piece also.

This illustration also contains all of the five folds. Study it carefully and see if you can find them.

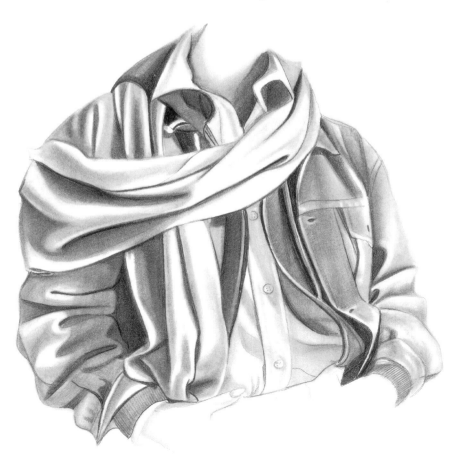

THE BODY SHAPES FABRIC

Before, we have been looking at just the clothing. Let's look at these examples and see how the figure affects the look. After all, it's the shape of the body underneath that gives the fabric its contours. Watch for how the fabric drapes off the model or wraps around the body and the way the fabric is stressed or pulled to create wrinkles and folds. Watch for how the body shape underneath affects the shadows and lighting.

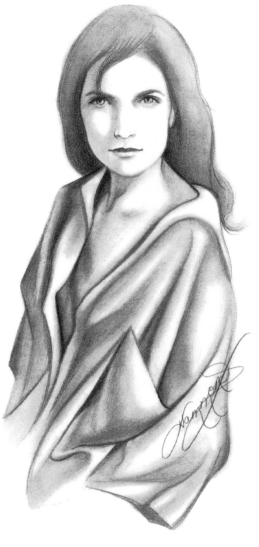

The column fold is created by the loose-fitting shirt draping off the model. The long hair, combined with the relaxed clothing, gives this fashion drawing a very casual look.

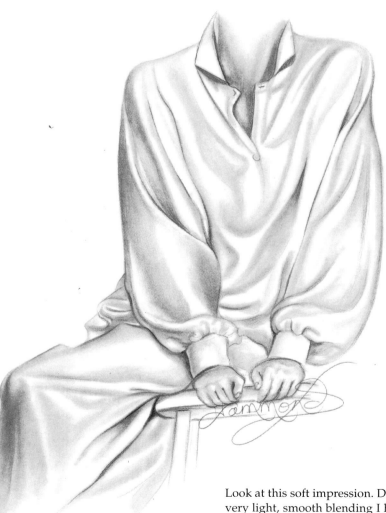

Look at this soft impression. Due to the very light, smooth blending I have created the illusion of silk. Study this carefully to see how I used reflected light to create the folds, creases and shapes within the fabric.

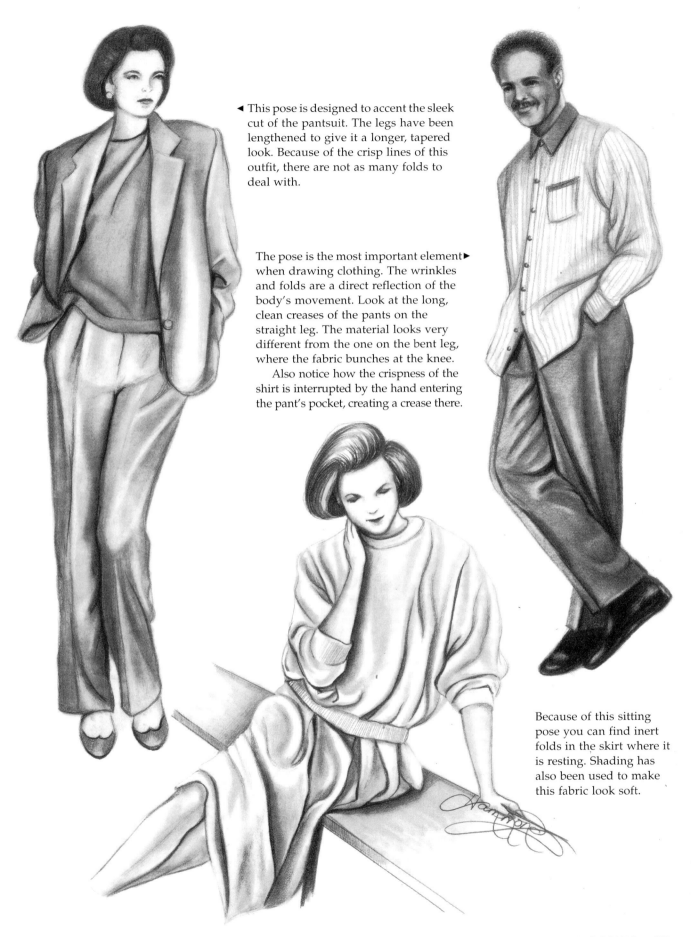

◄ This pose is designed to accent the sleek cut of the pantsuit. The legs have been lengthened to give it a longer, tapered look. Because of the crisp lines of this outfit, there are not as many folds to deal with.

The pose is the most important element ► when drawing clothing. The wrinkles and folds are a direct reflection of the body's movement. Look at the long, clean creases of the pants on the straight leg. The material looks very different from the one on the bent leg, where the fabric bunches at the knee.

Also notice how the crispness of the shirt is interrupted by the hand entering the pant's pocket, creating a crease there.

Because of this sitting pose you can find inert folds in the skirt where it is resting. Shading has also been used to make this fabric look soft.

CHAPTER SIX

TEXTURES AND PATTERNS

Until now we have been dealing mainly with folds and how they are seen on plain fabric. But what a dull world it would be if we wore nothing but solids. The reason fashion and costumes are so important to people all around the world is that they express our feelings and moods. They also define our cultures, demonstrate our beliefs and decorate our existence.

Stripes

Let's begin with the most popular pattern used in clothing: the stripe. It is important for any fashion designer or illustrator to accurately depict the way a pattern will look on a garment. A pattern will be interrupted by how the fabric moves, as seen in the striped outfits here.

Lucky for us, stripes are one of the easiest patterns to draw.

They are fairly easy to follow as they contour in and out of the folds around the body.

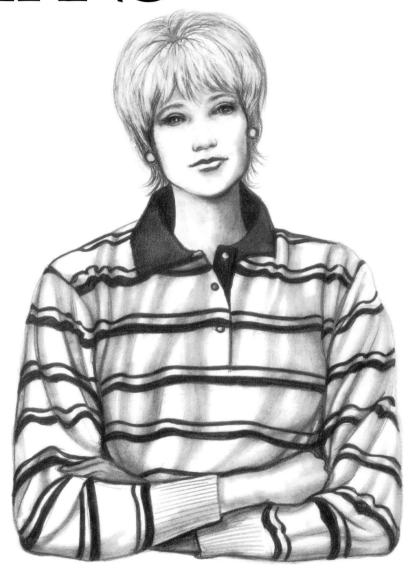

To draw this shirt I blended the folds first. This helped establish the shape before I began to apply the stripes. When drawing them in I was careful to see how they were affected by the fold underneath, and how they traveled in and out of each crease and wrinkle.

Since this was a double stripe, I was careful to keep the lines parallel to each other as I worked. The dark, contrasting collar of the shirt looks nice and helps the stripes stand out.

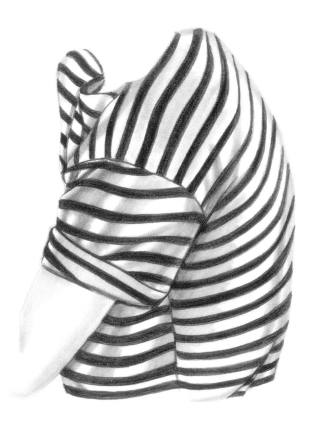

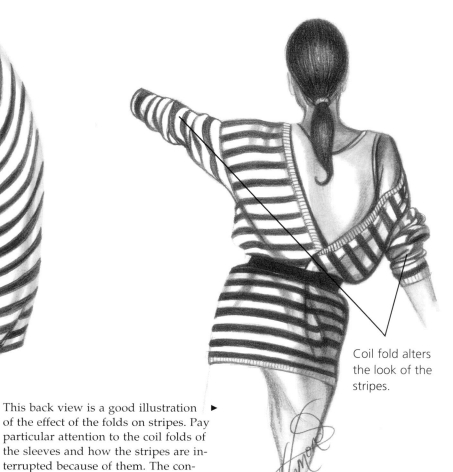

Coil fold alters the look of the stripes.

▲ Look at the perspective created by these stripes. Since the stripes are going away from our view, moving around to the back of the model, they seem to get smaller as they recede. Notice how the stripes of the sleeve are going in a different direction than the body of the shirt?

This back view is a good illustration ▶ of the effect of the folds on stripes. Pay particular attention to the coil folds of the sleeves and how the stripes are interrupted because of them. The contrasting belt and the darkness of the hair make this a striking, eye-catching illustration.

Striped Sleeve Exercise

This small step-by-step exercise shows you how to draw a striped outfit.

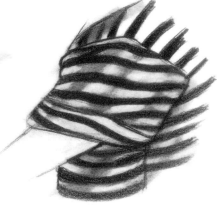

Draw the outline and the general shape.

Apply the shading to create the form.

Add the stripes, being sure to follow the shapes of the fabric. Notice how the shading still shows through? Sometimes I will apply the stripes first and then blend through them. You would then need to strengthen the color.

DENIM

Denim is one of my favorite fabrics to draw. It's best recognized by the double seams and the light and dark patterns found between them. Denim also has a somewhat porous look and the weave gives it a slight texture.

Look at how the light plays off the edges and seams of this jean jacket. Notice how I left unblended pencil strokes over the first layer of blending to create the denim-like texture.

Reflected light

Pencil marks are left behind to show fabric weave and texture.

The seams of this jacket show you right away that this is denim.

DENIM STEP BY STEP

Study this step-by-step example and try to draw it yourself. In the finished step, the illusion of denim has clearly been captured, mostly due to the seam of the jeans. Also, you can see the weave of the fabric from my pencil lines.

To draw the pant leg, begin with the basic shapes.

Block in your tones, placing your pencil lines in the direction of the fabric weave. Be sure to block in the creases and folds. Emphasize the seam of the jeans by using reflected light on both sides of the dark line.

Accentuate the seam and fabric texture.

Gently blend, allowing the texture to still show through. Reapply some weave lines to create even more texture and to give the fabric a more solid, rugged appearance. If necessary, lift some light out with your kneaded eraser for more contrast.

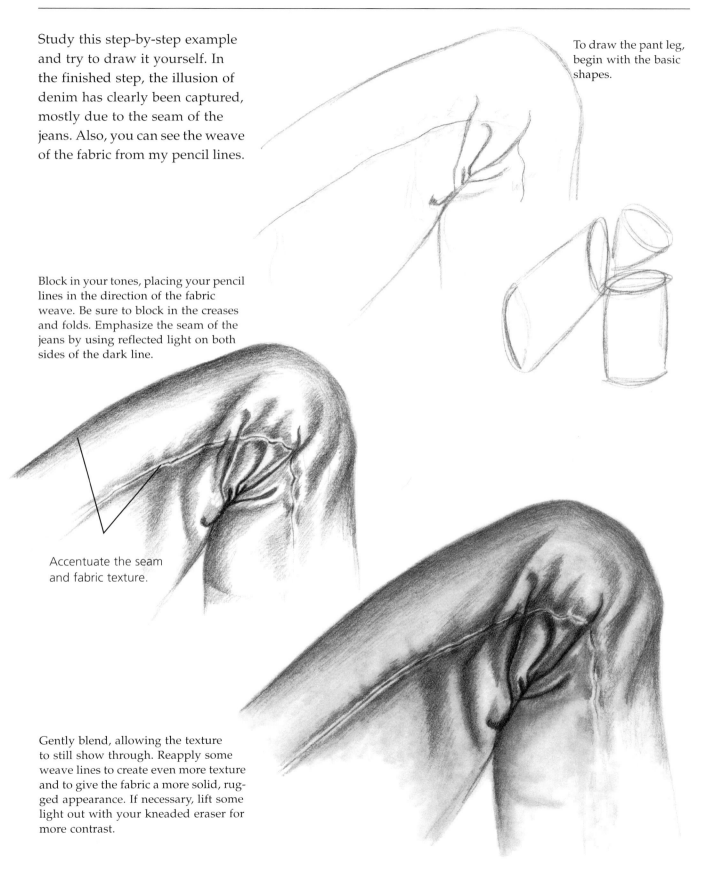

PLAIDS

Drawing plaids is very similar to drawing stripes, but more complicated due to the busy pattern involved. This illustration shows the rugged impression of a flannel shirt. You can see how all of the shirt's creases affect the pattern of the plaid, forcing the patterns and lines to go in many different directions.

This jacket sleeve has a tweedy plaid look, as well as a complicated pattern. Patterns such as this are easier to draw if tackled one small area at a time. With this example I filled in the tones one square at a time after drawing in the general pattern placement.

A rugged, plaid flannel shirt.

A plaid with a tweedy look to it.

PLAID SCARF STEP BY STEP

To help you draw plaids, try this step-by-step exercise.

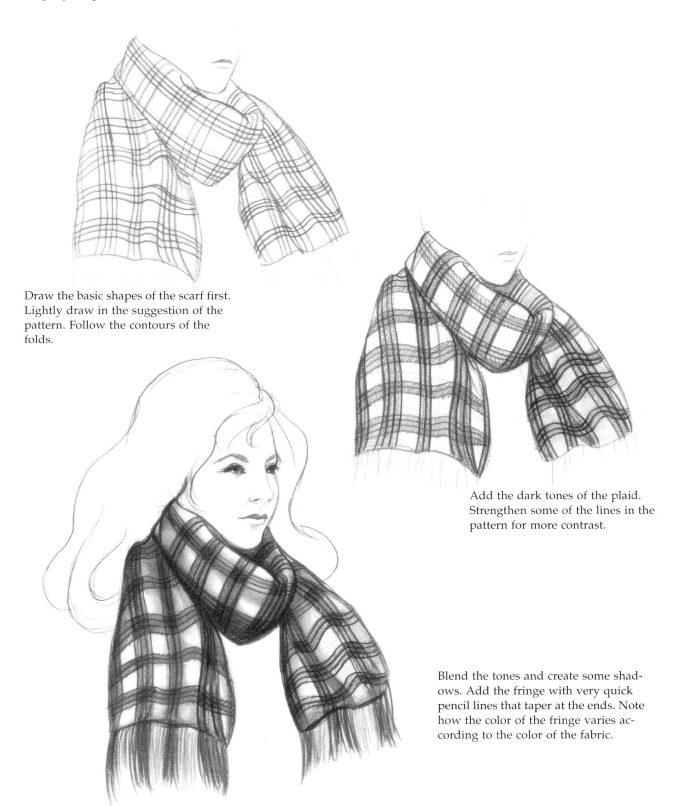

Draw the basic shapes of the scarf first. Lightly draw in the suggestion of the pattern. Follow the contours of the folds.

Add the dark tones of the plaid. Strengthen some of the lines in the pattern for more contrast.

Blend the tones and create some shadows. Add the fringe with very quick pencil lines that taper at the ends. Note how the color of the fringe varies according to the color of the fabric.

HARD EDGES

Fabric is not always smooth and gradual. Textures, weaves, seams and creases will often create extremely hard edges (see page 24 for an explanation of soft and hard edges). Hard edges will always create very obvious reflected light along them. Any raised surface will have reflected light along its edge.

Study this knit sweater. Each raised rib is lighter with the lower surface in its shadow. This gives it a definite texture. The ribs create a striped pattern that follows the bend of the fabric. Notice how there is also reflected light along the edge of the collar.

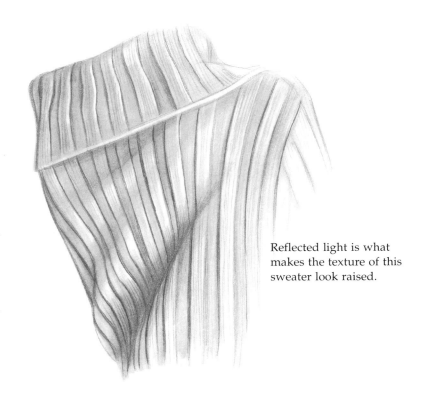

Reflected light is what makes the texture of this sweater look raised.

Exercise

Let's practice some hard edges with this pleated skirt.

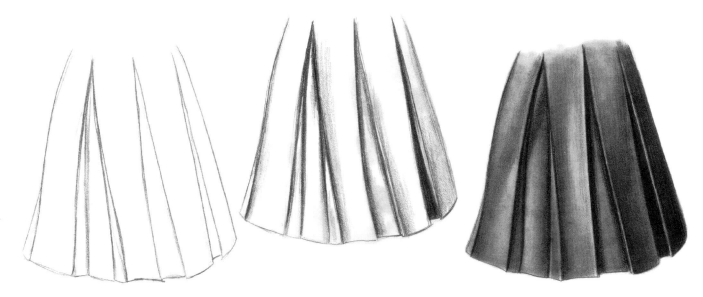

Look for the basic shapes first. This skirt is a cone shape. Each pleat within the skirt is also cone-shaped.

I added some strong, dark edges into the areas that recess, helping them make the other surfaces seem to come forward.

The blending creates the overall color of the skirt. The reflected light can now be seen along the edges of the pleats. To help with the illusion of a light source, I lifted out some additional light in the front of the skirt.

LACE

Lace is one of the most intimidating fabrics. However, it is really not as hard as it looks. There is a rule I devised for my students and I repeat it often. It is particularly true for drawing lace: "Light areas will show up only if there is a dark area next to it! So, draw the dark areas first and let them create the light areas for you." This exercise will show you how.

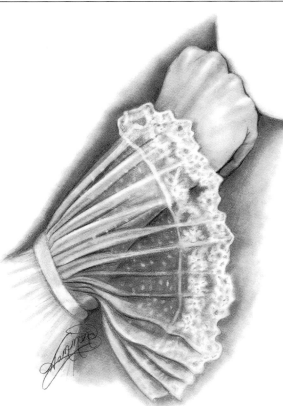

Always let the dark areas create the light ones for you as you draw. By placing the shaded background behind this drawing, the white edge of the sleeve can be seen more realistically. The rest of the drawing is merely a pattern of small shapes, with the application of light, medium or dark tones drawn into them. The small, light dots have been "lifted" with the kneaded eraser.

LACE STEP BY STEP

Draw the basic shapes in outline form. Give yourself a very light suggestion of the lace pattern. Don't worry if it's not exact. We are dealing with impression, suggestion and illusion here.

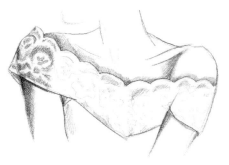

Begin to place in some of the dark tones along all of the light edges. Place in some dark values to begin suggesting the pattern.

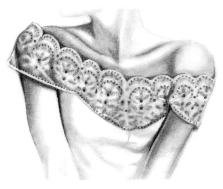

With your tortillion, blend the pattern out a little to soften it. Blend the skin area and the white fabric area below the lace.

Reapply dark tones to the lacy pattern. Lift out more white with your eraser between each of the dark areas to make them stand out. Continue playing with it by going back and forth, adding darks and lifting lights until it appears convincing to you.

FUR

Fur can also be an intimidating and confusing thing to draw, but it, too, is nothing more than darks, lights and shapes. Fur really is just layers and layers of quick little pencil lines all overlapping one another.

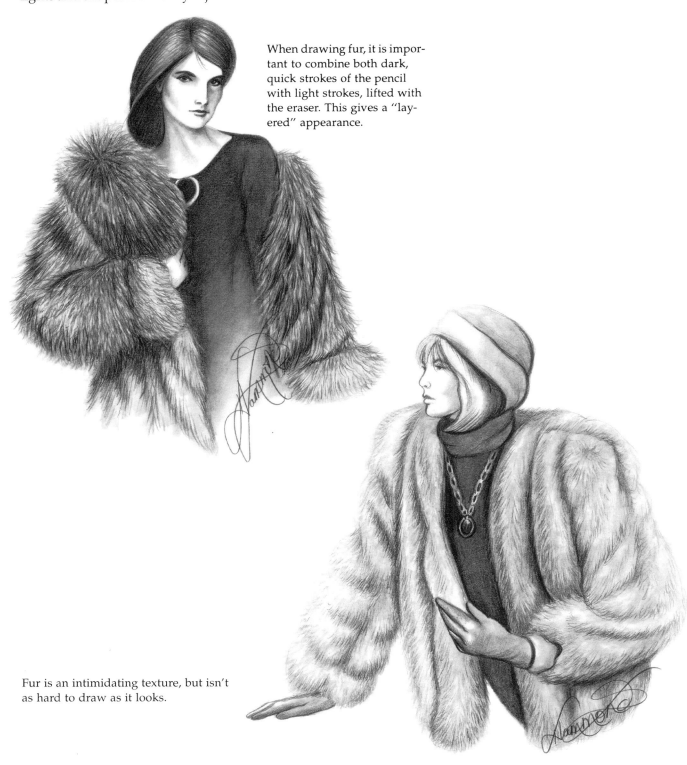

When drawing fur, it is important to combine both dark, quick strokes of the pencil with light strokes, lifted with the eraser. This gives a "layered" appearance.

Fur is an intimidating texture, but isn't as hard to draw as it looks.

A CLOSER LOOK

If you look closely, you'll see that small light hairs have been lifted out with the kneaded eraser. To do this the eraser is smashed between your forefinger and thumb into a razor edge. The light hairs are then lifted with the same quick strokes you used with your pencil. Clean the eraser after every three or four strokes to make a new edge and keep the light lines from becoming too wide.

This enlargement shows you the layers of quick, tapered pencil strokes and light hairs lifted out with the eraser.

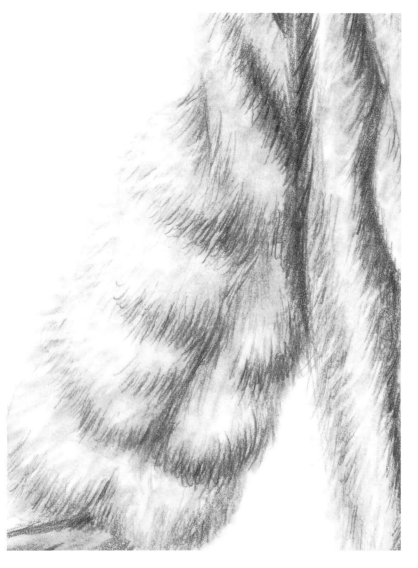

FUR STEP BY STEP

Practice fur by drawing this small shape.

Begin by placing in quick pencil lines. Go in the direction of the fur. Be sure to use a very quick stroke by flicking your wrist. Lightly blend a little with the tortillion.

Using the same quick stroke, create a razor edge with your eraser and lift out some light hairs.

DRAWING THE FASHION FACE

When you think of fashion illustration you probably think of clothing first, but the fashion face is every bit as important to the fashion industry. Fashion goes far beyond the outfit. Glamour includes hairstyles as well as makeup treatments. For this reason this chapter will focus on the female face.

As you can see, the eyes and lips are trying to communicate with you. They are inviting you to look closer and feel something when you do. This is the type of look that sells cosmetics.

By adding hair to this example, the drawing says a little more. Remember, illustration is used to communicate with you; to sell you on a look. It's as if the drawing is making eye contact with you.

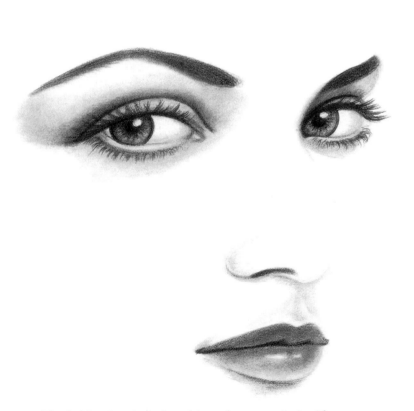

The fashion face is designed to make eye contact with you . . .

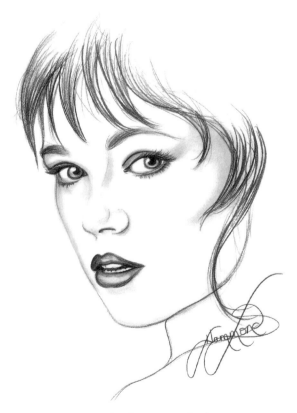

. . . and sell you on a look.

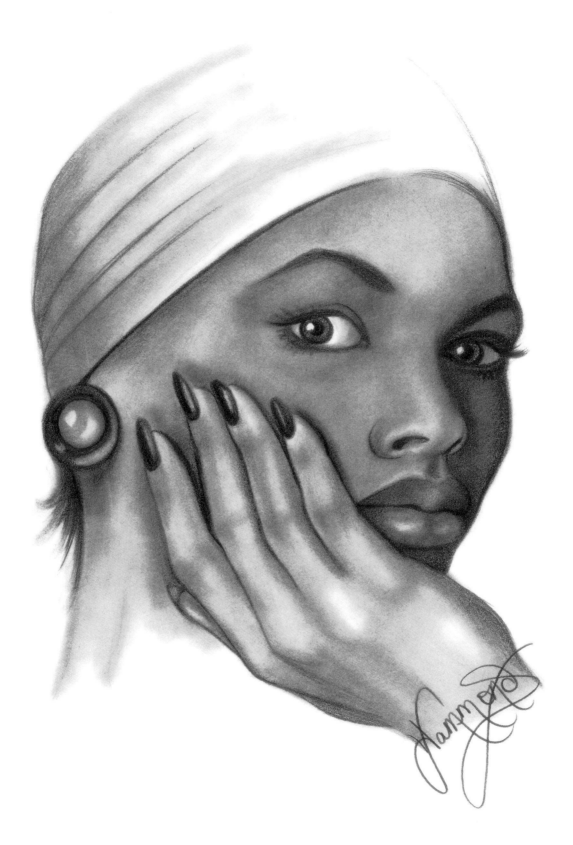

The gaze of this model is very direct, as if she were actually staring right at you. The graceful hand, combined with the dark, smooth skin tones, make this an eye-catching illustration.

EYES

The eyes are among the most expressive features of the face. A beautifully drawn eye is a work of art in itself and will make your fashion face come alive!

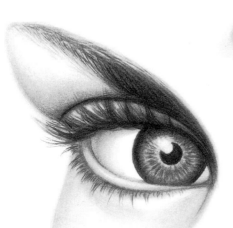

This sideward glance is a common fashion look.

Eyes can have many looks and expressions. Although this eye is still looking at you, the head is tilted down, making the eye appear seductive and piercing. It is the white below the iris that gives it this expression.

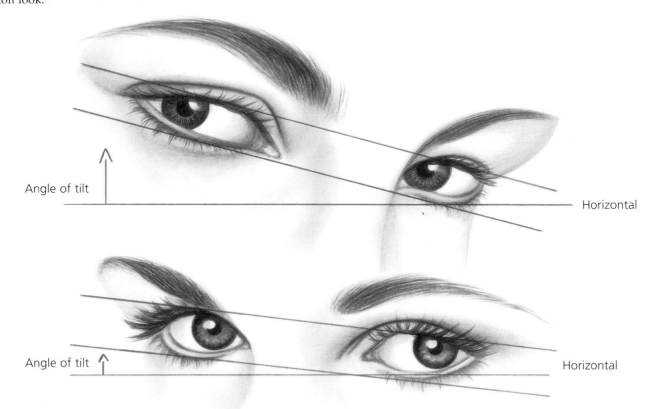

Angle of tilt
Horizontal

Angle of tilt
Horizontal

Be sure to watch the tilt of the head when drawing two eyes together. The eye closest to you will always appear a little bigger due to the nose partially blocking the other.

FASHION EYE STEP BY STEP

Here is a step-by-step exercise to show you how to capture the realism.

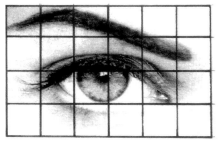

Using a graph, or grid, over your reference photo will help you draw the shapes of the eye more accurately.

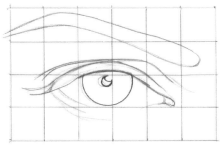

◄ Lightly draw a graph on your drawing paper the same as the one over the photo. Lightly sketch in the shapes of the eye using the grid as a guide. The iris and pupil are perfect circles. I always use a stencil or template to make them look nice. Many drawings of people do not look as good as they could because the eyes are not perfect circles.

When you are sure your line drawing is accurate, remove your grid from your paper with an eraser. Darken in the pupil, being sure to leave a catchlight, or highlight. This should be half in the pupil and half in the iris. Even if your reference photo has more than one catchlight, reduce it to just one.

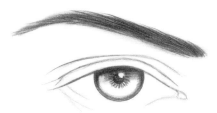

Place some tone in the iris to establish the eye color.

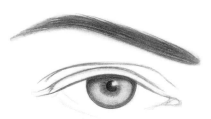

Gently blend the iris to make it look softer. Don't lose your catchlight!

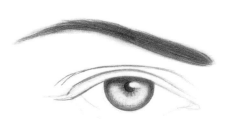

Lift out some light in the iris, to make it look shiny, and enlarge the catchlight for impact.

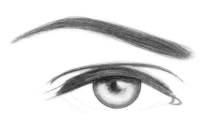

Fill in the lash line, as a foundation for placing the eyelashes, and darken the crease of the eyelid.

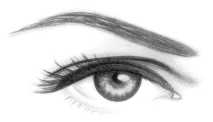

The finishing touches! Blend some tone above the lash line before you apply the eyelashes. This gives the impression of eye shadow. Carry the blending up into the eyebrow.

Apply the eyelashes with quick, curved strokes. Add some tiny lower lashes off the edge of the lower lid thickness. I added more eyelashes than in the photo to make it appear more glamourous.

LIPS STEP BY STEP

The mouth is also an essential element of the fashion face. This step-by-step guide will show you how to draw beautiful lips. We will be learning just the closed-mouth smile. For more detailed instruction on drawing the facial features, refer to my portrait drawing books: *How to Draw Life-like Portraits From Photographs*, or *Draw Real People!*

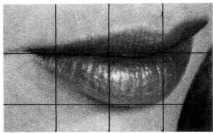

A grid will help you see the lips more accurately. Notice how, because of the slight turn of the head, you see more of the lips on the left than on the right.

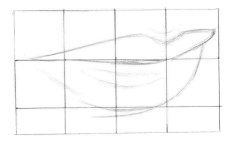

Lightly draw a grid on your drawing paper and create an accurate line drawing.

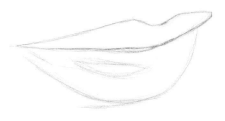

When the shapes are accurate, remove the grid from your paper.

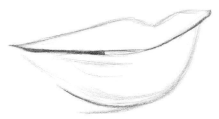

Apply some dark tone to the inside of the mouth.

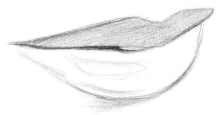

The upper lip is always darker than the lower lip. Apply the tone here first.

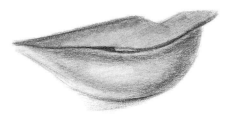

Add some tone to the bottom lip, leaving the area for the highlight.

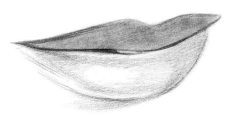

Gently blend the tones out until smooth.

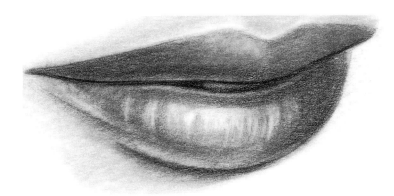

Add some shading around the mouth to create the reflected light around the edges. Lift the highlight out on the lower lip and reapply some of the dark tones for more detail.

EARS STEP BY STEP

Ears are important because they illustrate earrings and are closely linked to the look of the hair. They can be tricky to draw because they are made up of shapes within a shape. Study them carefully.

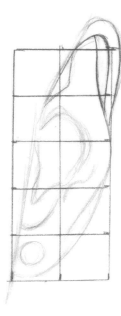

Use a graph to help you see the many shapes that make up the ear.

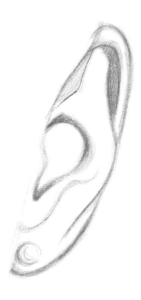

Start applying some tones in the recessed areas.

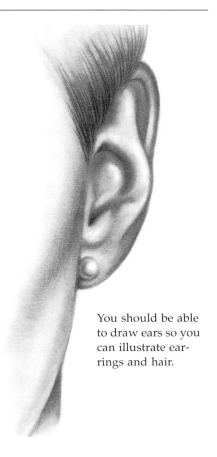

You should be able to draw ears so you can illustrate earrings and hair.

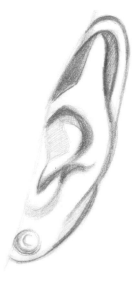

Continue adding dark and midtones.

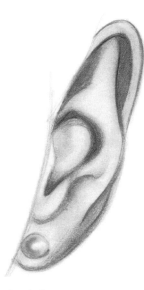

Blend the ear out to a smooth tone.

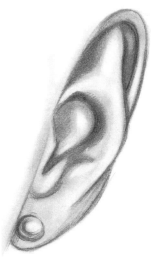

Lift out some of the highlight areas. This will make those surfaces seem to protrude.

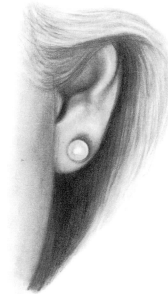

Look at how different the ear appears with the darkness of the hair behind it. Look how closely the pearl earring resembles the sphere exercise from chapter four.

CORRECT PLACEMENT AND PROPORTION

Accurate placement of the facial features is essential for quality fashion face illustration. This is an excerpt from my book, *How to Draw Lifelike Portraits From Photographs*. Follow these guidelines for proper feature placement.

In these illustrations you will see that the face and head can be divided into equal sections. If you look at line numbers one, two and three, you will see that line two marks the halfway point on the head—from the top of the skull to the bottom of the chin. Students are often surprised to see the eyes at the midway point and want to place the eyes too high. There is the same amount of distance between the top of the head and the eyes, as there is from the eyes to the chin.

Now look at line numbers one, four and five. You will see that line four is the halfway point. There is the same amount of distance between the eyes and the base of the nose as there is from the base of the nose to the chin. You can also see how the ears line up between lines five and four.

The dotted vertical lines show the relationship of the eyes to the nose, mouth and chin.

Now study the profile. The vertical line through the ear represents the halfway point to the thickness of the head. There is the same amount of distance between the back of the head and the ear as there is between the ear and the front of the cheekbone.

The vertical line in front of the eye shows that even in a profile, the middle of the eye lines up with the corner of the mouth. The angled lines show the outward thrusts of the brow bone and the upper lip.

The back of the head is really much shorter from top to bottom than the front. If you draw a line back from the nose and the ear, that's where the base of the skull meets the neck. The neck is not vertical, but tilts forward.

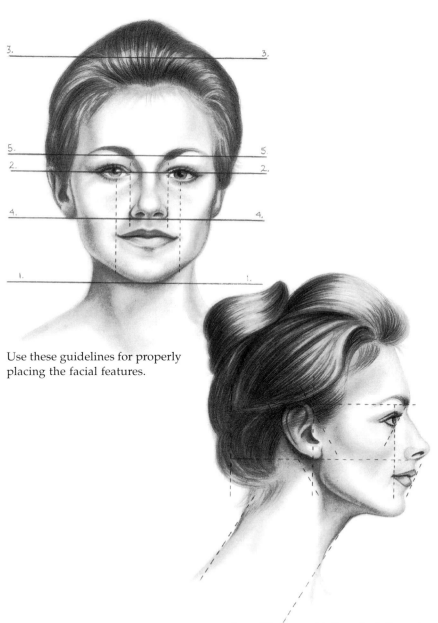

Use these guidelines for properly placing the facial features.

A profile has guidelines to follow also.

FASHION FROM PHOTOGRAPHS

This is an example of how I take a photograph and turn it into a fashion face. Use this graphed photograph for practice.

As you can see, I change the face considerably to emphasize the fashion and what it is I'm trying to illustrate with it. In this drawing I wanted the face to have a graceful, almost royal, quality with the emphasis on the jewelry.

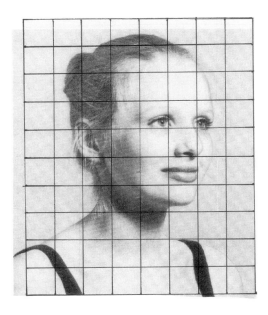

Use this graphed photograph to practice your own fashion face.

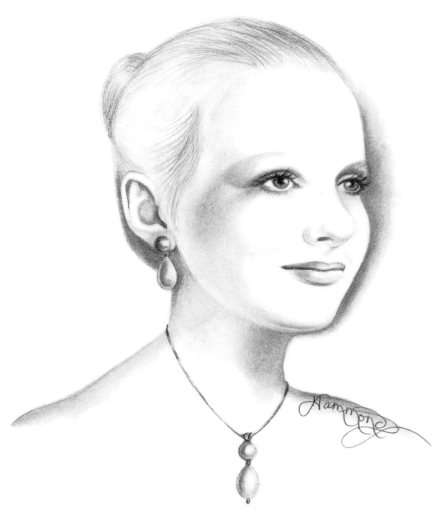

The grid helps you achieve an accurate line drawing with all of the facial features properly placed.

I changed the look of this model to create a fashion face as opposed to a portrait. I placed more detail and impact in the eyes and softened the overall impression of the face. The light shading behind the face helps it stand out. I added the earring and necklace to make it appear fashionable. I kept the hair details to a minimum so as not to take away from the face and jewelry.

THE FASHION FACE PHOTOGRAPHED

This is an example of a beautiful fashion photograph. The lighting has been especially designed to cast interesting shadows onto the right side of the face. The darker background helps the reflected light along the side of the face show up. The radiating lines of the fan in the background lead your eye to the center of the photograph—to the model.

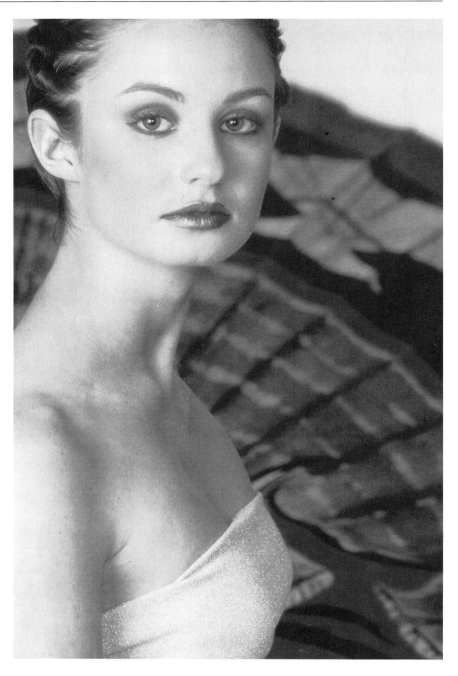

A fashion photograph. Model: Kayce Kahl

THE FASHION FACE ILLUSTRATED

Just as you can alter the figure to make it more fashionable, you can also exaggerate and embellish the face for fashion reasons. Although fashion photography is beautiful, there are things you can do in a hand-drawn illustration that you simply can't achieve through photography.

This drawing was done using the previous photograph for a reference. As you can see, I greatly simplified it—placing even more impact on the face.

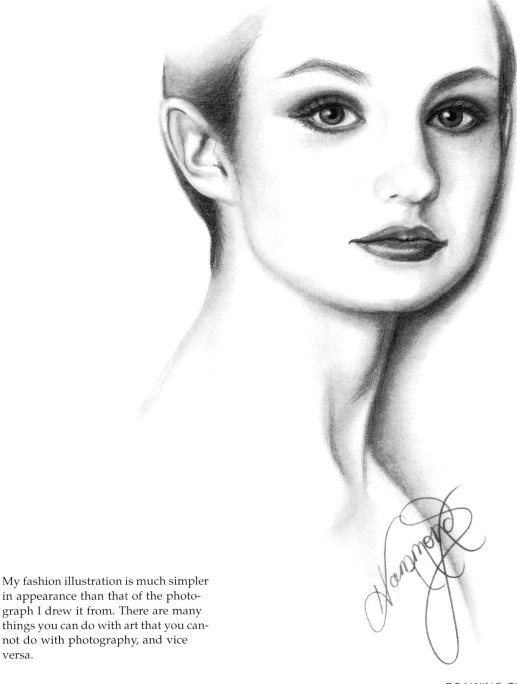

My fashion illustration is much simpler in appearance than that of the photograph I drew it from. There are many things you can do with art that you cannot do with photography, and vice versa.

DRAWING FASHION HAIRSTYLES

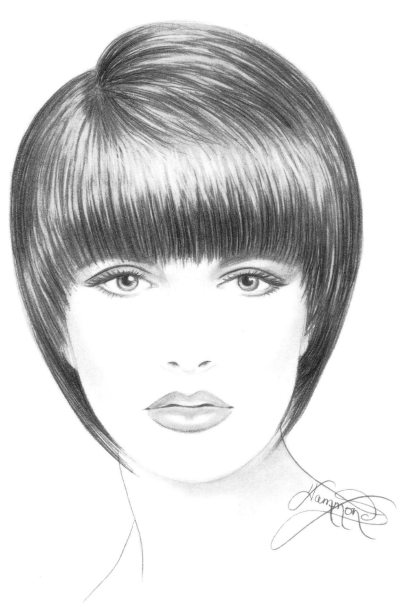

The fashion face is used to sell and promote not only cosmetics and a fashionable look, but also hairstyles. The fashion face combines the glamourous look of makeup with the latest trend in hairstyles to create a total fashion statement.

This illustration is a good example of a direct fashion expression. It grabs your attention with its eye contact. The hairstyle frames the face, leading your eye back to the eyes and mouth.

Notice how little detail has been put into the face. The nose has been diminished so the eyes and mouth will stand out more. This chapter will act as a step-by-step guide to some of the more popular hairstyles and types.

HIGHLIGHTING TECHNIQUES

I am a very realistic artist, but with fashion illustration, I will often combine my realistic techniques with graphic line drawing to give my art an eye-catching appeal. This example shows you this technique.

The hair in this drawing is the main focus. This is what the drawing is trying to sell to the viewer. By drawing it realistically, you can see how it works with the face to create a fashion look. By sandwiching the realistic drawing style between the line drawing approach of the hat and neckline, the emphasis is then placed on the hair and face—right where I want it! This drawing has a somewhat sporty look to it.

The second illustration, on the other hand, has a more serious tone. Again, it is the hairstyle that is being highlighted. This in turn creates an impression for the viewer, and conveys the business-like attitude of the model. The hairstyle looks very neat and kept; what someone would wear in an office environment. The shoulders of the outfit look like it could be a business suit.

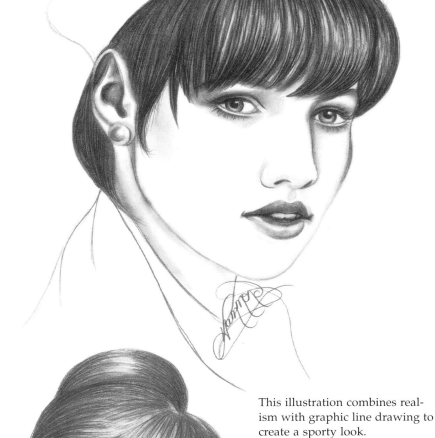

This illustration combines realism with graphic line drawing to create a sporty look.

The hairstyle and attitude of this drawing appears businesslike.

HAIRSTYLE EXERCISES

Whether the hair is long or short, light or dark, the process for drawing it is much the same. The difference lies in the length of the pencil lines and the depth of tone. Although these hairstyles are completely different, the same basic procedure can be used for each.

The following exercises will help you learn some of the most common fashion hairstyles.

Dark Hair

Always begin the hair by seeing it as one large, continuous shape. Look for the part of the hair and any areas of separation.

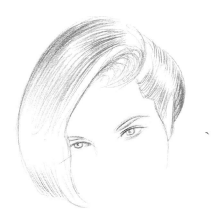

To apply the tones of the hair, you must always use very quick pencil lines. This will keep the lines soft and tapered on the end (as in the fur example on page 44). Always apply the lines in the same direction until the hair begins to fill in. Leave highlight areas a little lighter than the rest. Note how the pencil lines come out from the part and curve, giving the hair its fullness. The wave and shape of the hair is clearly established now.

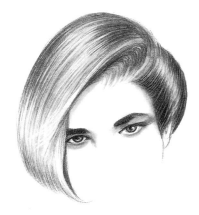

Blend the hair out with your tortillion. This makes it much fuller and begins to give it the layered look. Reapply the dark tones until you have the depth of tone needed to represent the hair color.

With your kneaded eraser, smashed between your thumb and forefinger into a razor edge, begin to lift your highlight areas. With the same quick strokes you used to apply your pencil lines, draw in some light strokes with the eraser. It will be important to clean your eraser and create a new edge after every two or three swipes. If the light areas become too bright, or uneven, use quick strokes of your pencil to reapply some dark lines. This helps the lights and darks work into one another.

Light Hair

Light hair is done in much the same way, but it is not nearly so work-intensive. Always begin with the hair drawn lightly as a basic shape.

Apply your pencil lines quickly to establish the hair direction. Leave the highlight areas. Can you see the roundness of the hairstyle beginning to form?

Blend the tones through. Reapply quick pencil strokes to give the hair a little texture and body.

Lift the highlights with the eraser as in the previous example. Look at how I created some light hair overlapping the other.

Long Hair

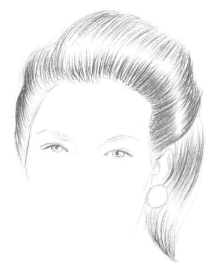

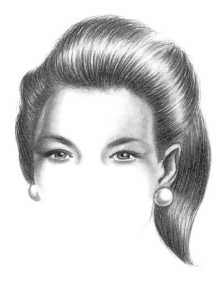

Draw the outline shape.

Apply the pencil lines to establish hair direction. Look for the band of light that is creating the roundness of the hair.

Blend the tones. Reapply the pencil lines for texture and depth of tone. Lift the highlights to create the shine.

Men's Hair

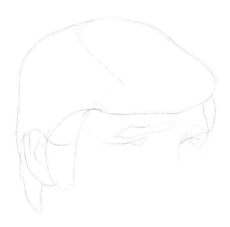

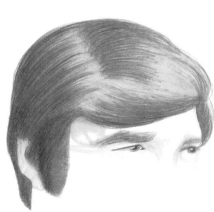

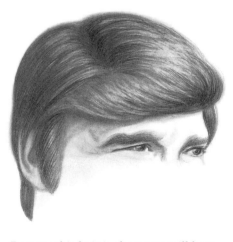

Draw the basic outline.

Fill in the hair with lines going with the hair direction. Blend your tones.

Because this hair is short you will have to lift more with the eraser to create its many layers. Go back and forth between the eraser and pencil until it seems full and lifelike.

Wavy, Permed or Curly Hair

Hair that is wavy, permed or naturally curly presents more of a challenge. But with practice, it can be a fun thing to draw and a very nice addition to a fashion illustration. The following will show you the process for making it look convincing.

Once again, create the overall shape of the hair, being sure to establish the waves and curls.

Look for the light and dark patterns created by the wave, and apply the dark tones. Be sure that your pencil lines represent the hair direction.

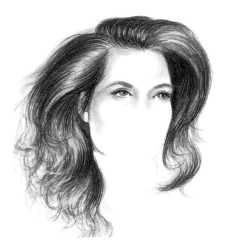

As before, blend the drawing out and reapply the darker pencil lines. It is now important to show overlapping hair. This is created by alternating the pencil lines with lines lifted with the eraser. Make them look wild and tapered.

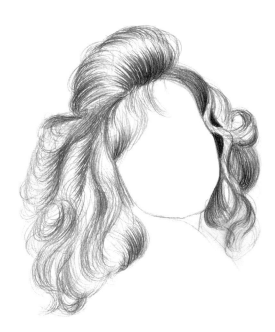

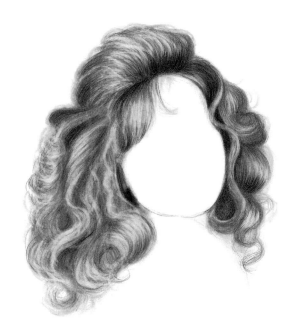

This example represents a very thick, full head of wavy hair. Create the fullness with your pencil lines. This style has many individual shapes of light and dark. Each curl has its own set of shadows and highlights.

The eraser has done a lot of the drawing in this illustration. Each curl and wave had areas that needed to be lifted. The wispy, overlapping stray hairs were also lifted. It took many layers to complete this drawing. With a hairstyle such as this I always tell my students to be very patient and not to quit too soon.

Ponytails

Ponytails are very common in the world of fashion. They give the model a clean, orderly look, one that keeps the hair from competing with the face and clothing.

As you will see from the exercises, a ponytail is an easy hairstyle to draw.

Exercise #1

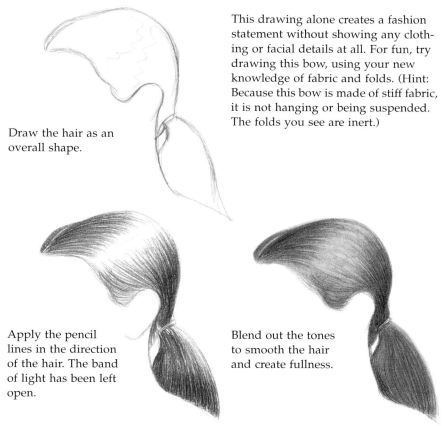

Draw the hair as an overall shape.

This drawing alone creates a fashion statement without showing any clothing or facial details at all. For fun, try drawing this bow, using your new knowledge of fabric and folds. (Hint: Because this bow is made of stiff fabric, it is not hanging or being suspended. The folds you see are inert.)

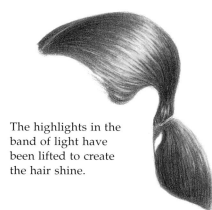

Apply the pencil lines in the direction of the hair. The band of light has been left open.

Blend out the tones to smooth the hair and create fullness.

The highlights in the band of light have been lifted to create the hair shine.

Exercise #2

Use the same process as above to complete this ponytail.

Draw the overall shape.

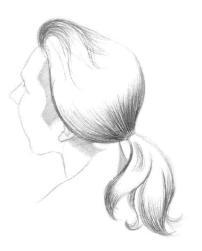

Apply pencil lines and indicate light areas.

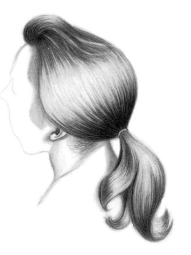

Blend and smooth tones and lift highlights.

DRAWING THE HANDS

Hands are often essential to an illustration. They are very expressive and can do much for a pose to create a mood and feeling.

Although hands are often made smaller in a fashion illustration, as you have seen in previous chapters, they can also be made the center of attention. It all depends on the motive for your drawing and what you are trying to say to the audience.

These photos show you how the hand placement, combined with a slight change of expression, can alter the entire mood of the picture.

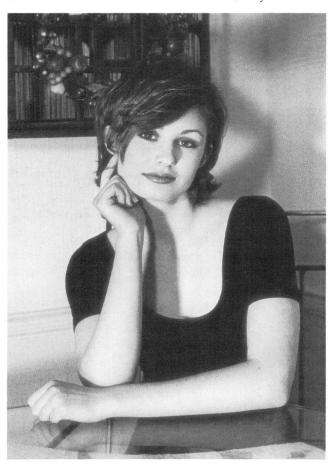

This pose and expression appear confident and matter of fact. The model appears sure, but relaxed, due to the pose of the hands.

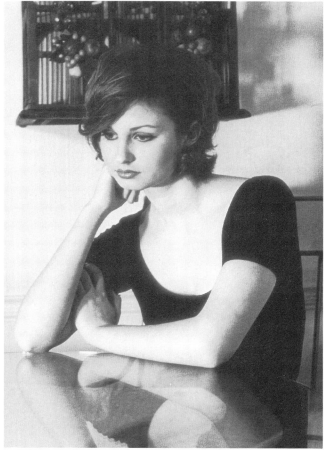

This arrangement and expression make her appear sullen and lost in thought. With the hand supporting her face, it gives the model a more serious look than the photo before. The placement of the hands has helped change the entire mood of the picture.

PROPORTION

In reality the hand is about the size of the front of your face. In fashion, if the hands are down by the sides, it is common to draw them a little smaller to downplay them.

However, when the hand is drawn next to the face, proper proportion is important to make them look believable. The following drawings will show you why.

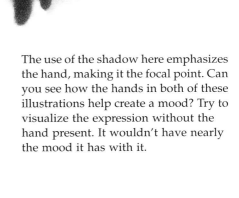

The use of the shadow here emphasizes the hand, making it the focal point. Can you see how the hands in both of these illustrations help create a mood? Try to visualize the expression without the hand present. It wouldn't have nearly the mood it has with it.

This illustration would be good for an ad that needed to sell a mood, perhaps perfume or a type of makeup. It has a serious quality, with the hand giving the model an attitude of deep thought.

REALISTIC HANDS STEP BY STEP

Here is a quick lesson in hand drawing and what to look for when drawing hands for fashion (see illustration at right).

Now draw the whole hand step by step with shading and blending for a finished rendering.

First, study the photo, then the placement of shapes within the boxes of the graph. Look for positive shapes (the hand and fingers) and negative shapes (the background). Make an accurate line drawing at this stage. Don't add tone until you're sure none of the shapes will have to be altered. It's hard to correct shapes that have been filled in with tone. This is what your line drawing should look like at this stage.

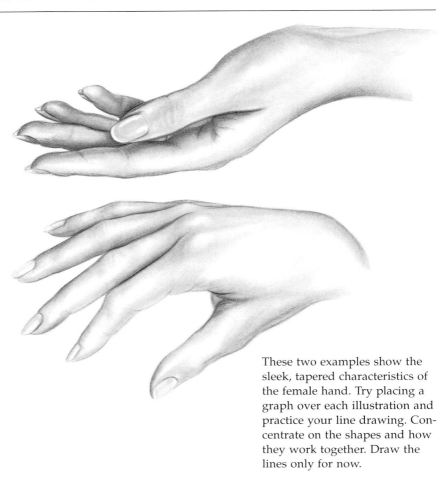

These two examples show the sleek, tapered characteristics of the female hand. Try placing a graph over each illustration and practice your line drawing. Concentrate on the shapes and how they work together. Draw the lines only for now.

Look for the light source in this photo. See how the front of the hand is lighter and the back of the fingers are darkened by shadow?

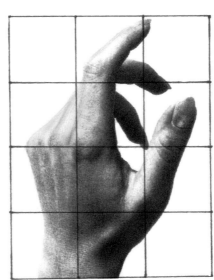

Placing a graph over a photo helps you to see and draw the shapes more accurately.

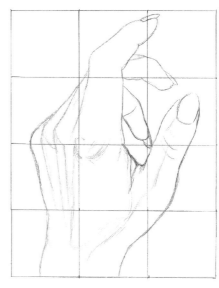

Look for the positive and negative shapes. Be sure that your line drawing is accurate before you continue with the blending and shading.

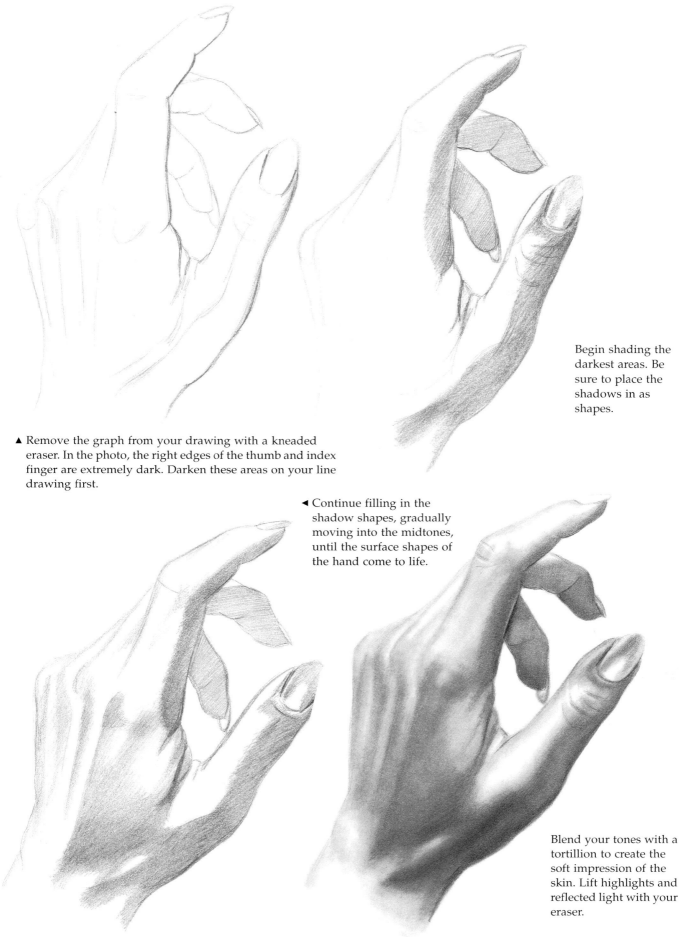

Begin shading the darkest areas. Be sure to place the shadows in as shapes.

▲ Remove the graph from your drawing with a kneaded eraser. In the photo, the right edges of the thumb and index finger are extremely dark. Darken these areas on your line drawing first.

◄ Continue filling in the shadow shapes, gradually moving into the midtones, until the surface shapes of the hand come to life.

Blend your tones with a tortillion to create the soft impression of the skin. Lift highlights and reflected light with your eraser.

DRAWING FASHION ACCESSORIES

Accessories are the fashion extras that go along with the outfits and the makeup to enhance and pull together the entire fashion look. These accessories include, but are not limited to, shoes, purses, belts, glasses, hats, gloves and jewelry.

All of these things can be fun to draw because of the different textures they have. When I taught a college course in fashion illustration, I had my students collect fashion magazines. Part of their homework was to go through

them and practice drawing all of the accessories they could find. I also took them on field trips to the mall and had them draw from mannequins on display. I invite you to do that as well—it is wonderful practice work. It's fun and interesting to explore the different colors and textures of fashion.

Legs

Legs are an important element in fashion drawing although they are often cut off in the illustration

to make them seem longer and the model appear taller.

These examples have a lot of roundness due to the shading. Look for the five elements of shading in these drawings.

One thing to look for when drawing legs is the ankles. The ankle bones are not directly across from one another. The bone on the inside of the leg is higher than the bone on the outside. If you draw them straight across, the leg will appear too thick.

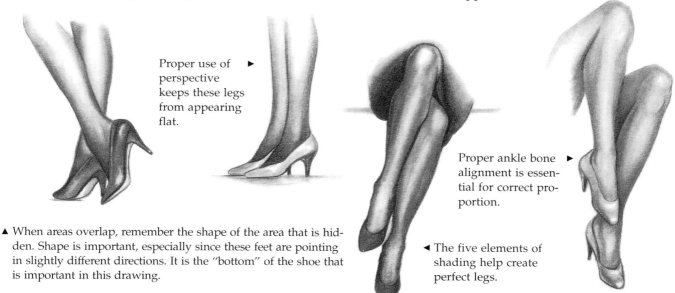

Proper use of perspective keeps these legs from appearing flat. ▶

▲ When areas overlap, remember the shape of the area that is hidden. Shape is important, especially since these feet are pointing in slightly different directions. It is the "bottom" of the shoe that is important in this drawing.

Proper ankle bone alignment is essential for correct proportion. ▶

◀ The five elements of shading help create perfect legs.

FOOTWEAR

Legs can be fun to draw and are essential if you are going to illustrate footwear.

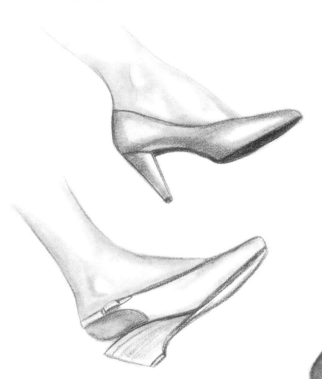

◄ This is a foot in perspective. It is the way you would normally see it when someone is standing straight on. What you see is a foreshortened view of the foot. This means that the length of the foot seems shorter than normal because it is projecting forward, causing the distance to appear distorted. This is a very important element to overcome in your drawing. The unexperienced artist will always have problems drawing foreshortened views. I suggest you study as many shoe references as you can find. Truly look at the shapes and how they are being altered by perspective. The more you practice the better your artwork will be.

▲ Look at how the two different poses of these feet alter the shape of the foot. In the first example, the top of the foot has a much more pronounced arch to it, due to the position of the foot and the height of the shoe's heel.

The upward thrust of the foot in the second example makes the top of the foot seem less curved.

These two feet appear to be in mid-stride. See how the stance and weight bends the foot. It causes a crease to form where the toes begin, about where the edge of the upper shoe hits the foot.

Look at the arch of the feet in the high heels. This also shows you the ankles and how the outside bone is lower. The contrast of extreme dark against light helps make these shoes look like patent leather.

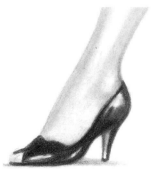

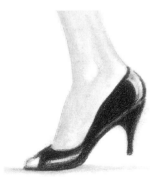

VARIOUS ACCESSORIES

Here are a few examples of the different accessories you can practice. Each one will have its own set of artistic challenges for you to work through. Again, I invite you to draw from magazines as much as possible for practice work.

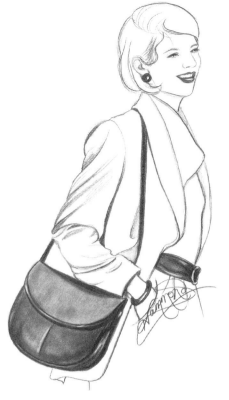

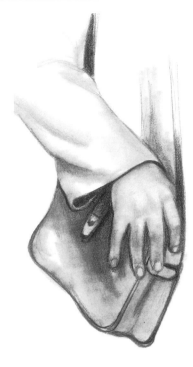

Neckties are very common in fashion, but I have seen many drawn inaccurately. The result is a tie that looks flat and shapeless. Applying the five elements of shading will lend more dimension to the knot area. Also look for how the fabric is creased where it comes out of the knot.

See how the stripes in the shirt collar follow the roundness of the neck.

This line drawing, combined with realism, draws your attention to the accessories. The belt and the purse have been drawn to match each other. The bracelet and the earrings also match. I darkened the model's lips to help balance the dark tones of the drawing.

The arm and hand create strong cast shadows on this purse. The smooth blending gives it the look of leather.

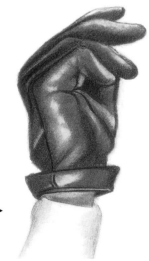

Blending the tones gives this ▶ glove the look of smooth leather. The highlights give it a shine.

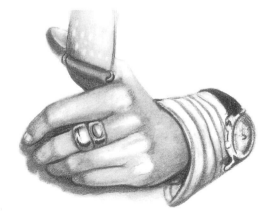

◀ You can see the importance of drawing hands as well as stripes and jewelry in this pose. When drawing shiny objects you must exaggerate the contrasts. The light and dark shapes of the rings have been drawn with precise patterns. The extremes help them appear to shine.

The watch offers a perspective problem. Because the watch is turned slightly, its face is no longer a perfect circle. It is now an ellipse. Notice the shine, or glare, across the watch's face.

PEARLS AND BEADS

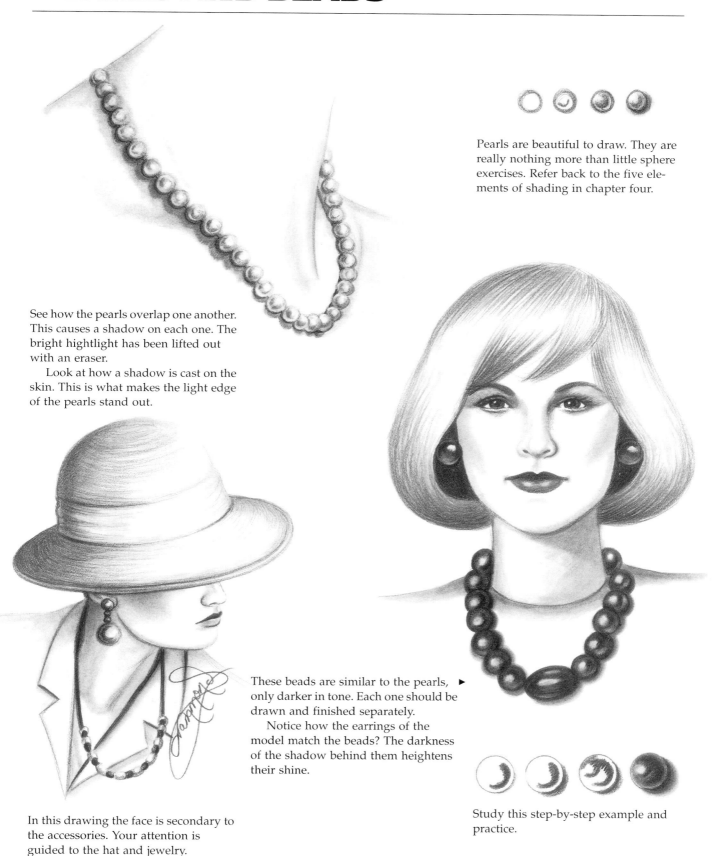

Pearls are beautiful to draw. They are really nothing more than little sphere exercises. Refer back to the five elements of shading in chapter four.

See how the pearls overlap one another. This causes a shadow on each one. The bright hightlight has been lifted out with an eraser.

Look at how a shadow is cast on the skin. This is what makes the light edge of the pearls stand out.

These beads are similar to the pearls, ► only darker in tone. Each one should be drawn and finished separately.

Notice how the earrings of the model match the beads? The darkness of the shadow behind them heightens their shine.

In this drawing the face is secondary to the accessories. Your attention is guided to the hat and jewelry.

Study this step-by-step example and practice.

ACCESSORIZED ILLUSTRATIONS

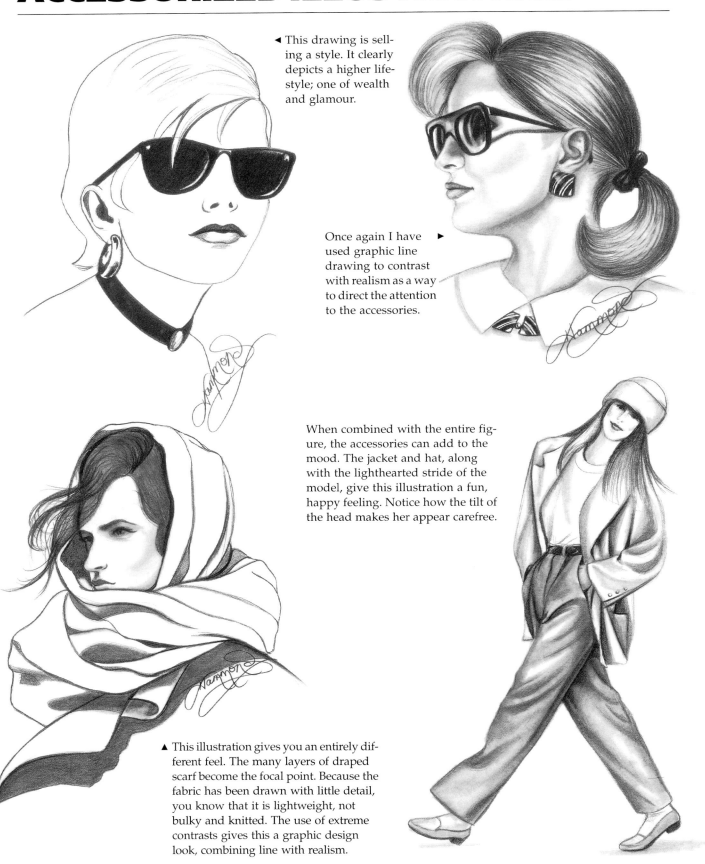

◄ This drawing is selling a style. It clearly depicts a higher lifestyle; one of wealth and glamour.

Once again I have used graphic line drawing to contrast with realism as a way to direct the attention to the accessories. ►

When combined with the entire figure, the accessories can add to the mood. The jacket and hat, along with the lighthearted stride of the model, give this illustration a fun, happy feeling. Notice how the tilt of the head makes her appear carefree.

▲ This illustration gives you an entirely different feel. The many layers of draped scarf become the focal point. Because the fabric has been drawn with little detail, you know that it is lightweight, not bulky and knitted. The use of extreme contrasts gives this a graphic design look, combining line with realism.

SOFTNESS FROM INTENSE TEXTURE

I like this illustration mostly for the intense texture of the hat and scarf. It was fun drawing the patterns, making them replicate the feeling of cable knit. I used the darks and lights to give a woolly, soft impression. This was done by going back and forth between my pencil and eraser, after the entire drawing was blended, to enhance the shadows and highlights.

The cuff of the glove also has a fuzzy appearance. It, too, was achieved with the shading and lifting of light.

Although I will sometimes leave the face of the model less detailed to accent the accessories, I rendered this one fully. The result is more of a portrait-quality illustration, one that gives the personality some warmth.

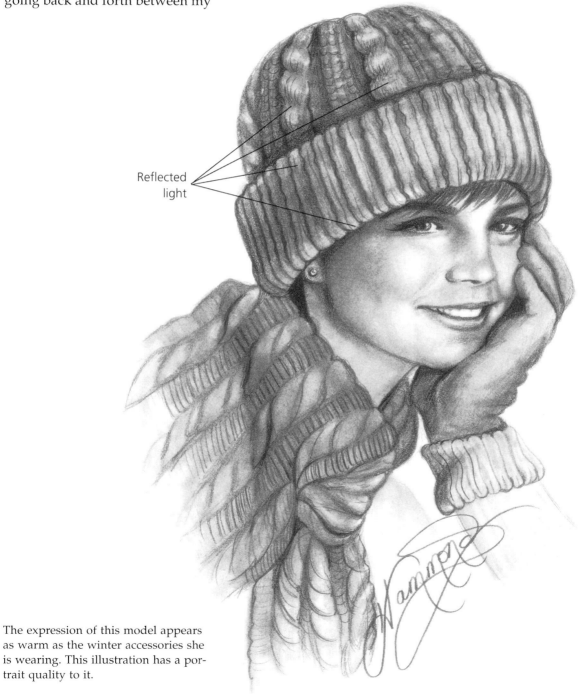

Reflected light

The expression of this model appears as warm as the winter accessories she is wearing. This illustration has a portrait quality to it.

CHAPTER ELEVEN

SPECIAL EFFECTS

You, as an artist, can decide how far you want to take your illustrations. You can make them very realistic, somewhat abstract or give them a graphic impression. The choice is yours, as long as you are still telling a story to your viewer. The following examples will give you some ideas for dressing up your work and being a bit more creative with your delivery.

In many of my drawings, not just fashion illustration, I use a technique called *border boxing*. It takes your image and makes it appear as if it were projecting out of a box.

In this example I used line drawing. I darkened the background areas of the box to help the figure stand out. To balance the tones, I darkened in the T-shirt and shadow side of the hat, lips, earrings and buttons. The result is a very crisp, clean graphic look.

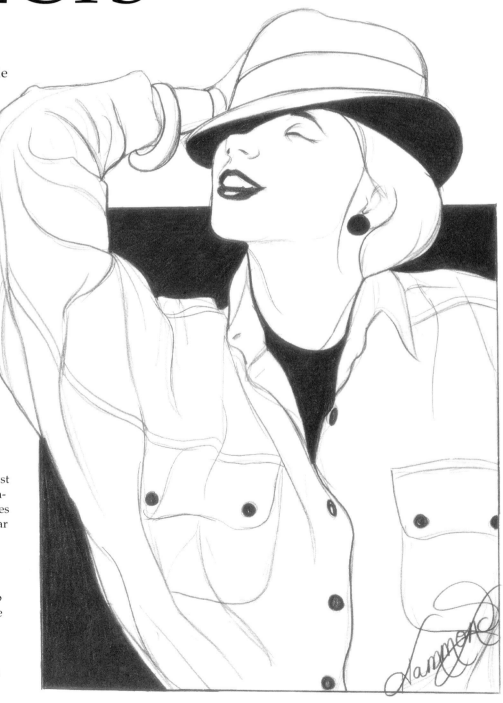

BORDER BOXES

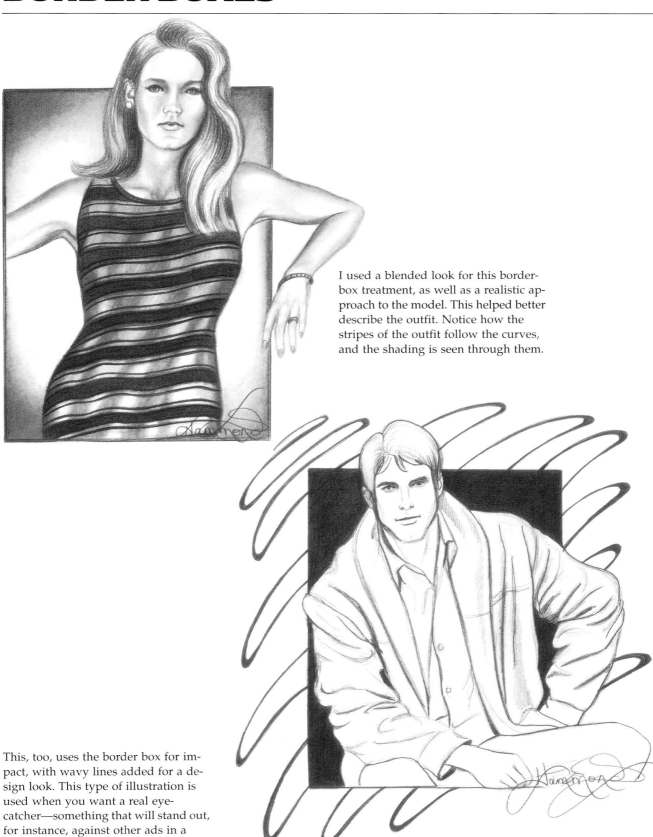

I used a blended look for this border-box treatment, as well as a realistic approach to the model. This helped better describe the outfit. Notice how the stripes of the outfit follow the curves, and the shading is seen through them.

This, too, uses the border box for impact, with wavy lines added for a design look. This type of illustration is used when you want a real eye-catcher—something that will stand out, for instance, against other ads in a newspaper.

SHADING EFFECTS

Blending and shading can accent your artwork in many ways. They can give your work a very realistic soft look or a very direct, bold impression. The examples here will show you both effects.

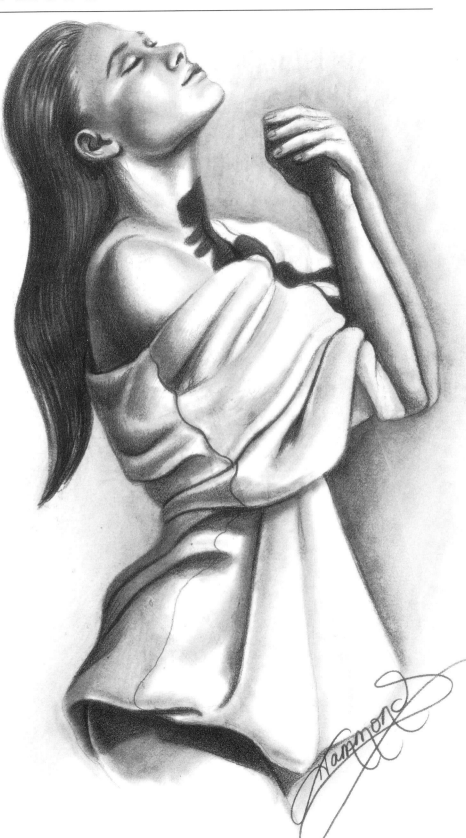

The blending and use of shadows make this artwork appear almost dreamlike. If you study its technique, you will find the five elements of shading are its basis. Look at the different types of folds in the clothing and the reflected light.

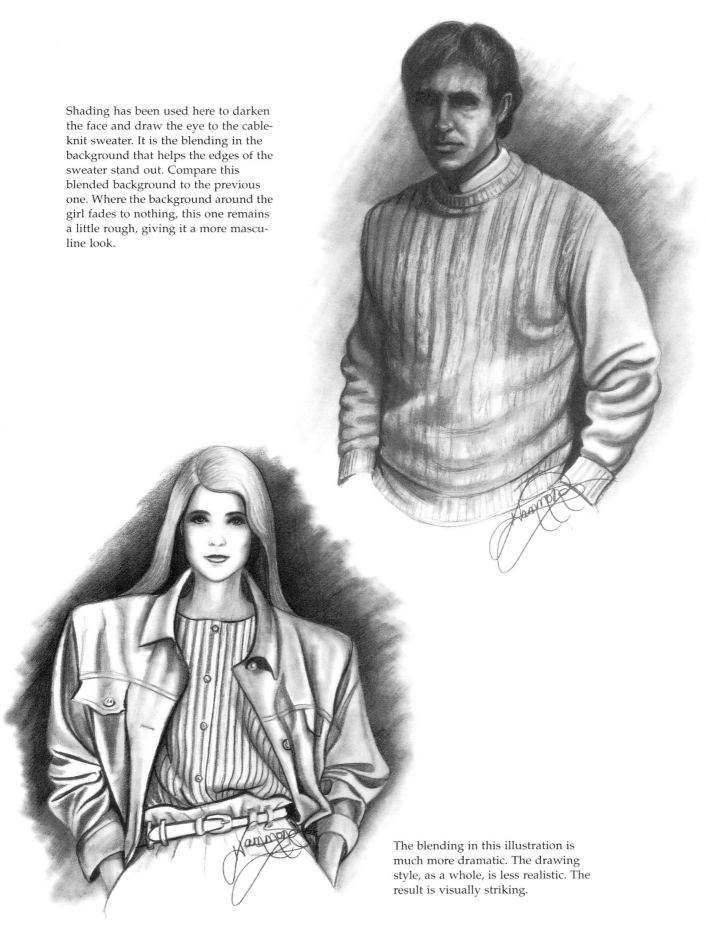

Shading has been used here to darken the face and draw the eye to the cable-knit sweater. It is the blending in the background that helps the edges of the sweater stand out. Compare this blended background to the previous one. Where the background around the girl fades to nothing, this one remains a little rough, giving it a more masculine look.

The blending in this illustration is much more dramatic. The drawing style, as a whole, is less realistic. The result is visually striking.

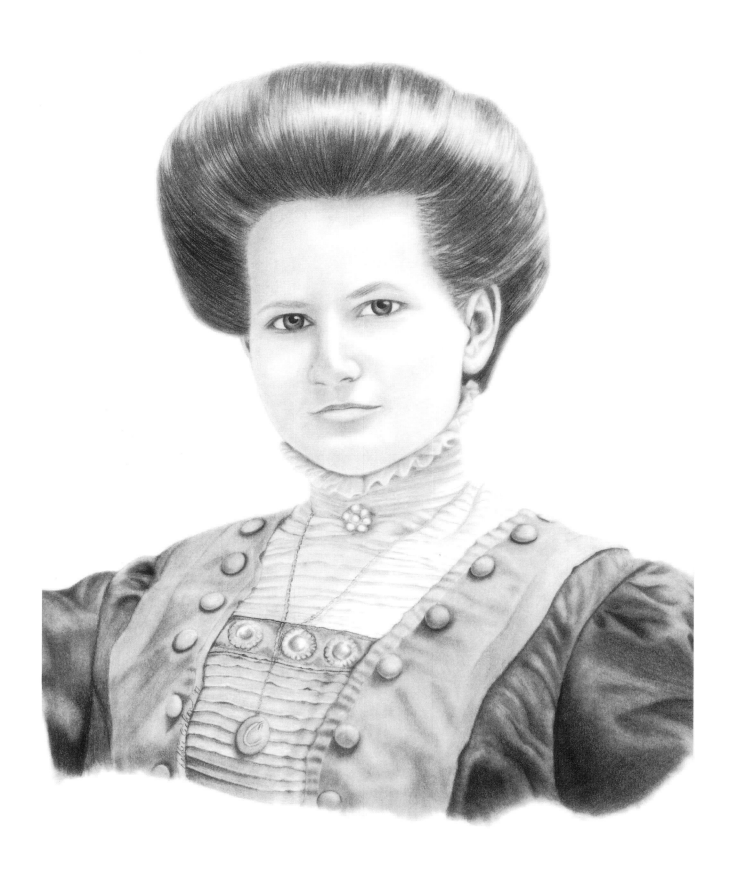

PORTRAYING A LIFESTYLE WITH FASHION TECHNIQUES

Fashion illustration doesn't always mean glitz and glamour. Sometimes it is used to portray a lifestyle or an era in time.

This beautiful drawing was done by a student of mine who fell in love with this period costume. She worked for months to accurately depict the details of this early-ninteenth-century dress.

Study this carefully. Look at all the overlapping ridges of fabric on the collar and bodice. Each one of these ridges has an edge of reflected light. Look at how the shadow under the ruffle of the neckline makes it appear to stand out.

Shadows can also be seen under each of the covered buttons. The smooth blending on them makes you know that they are fabric-covered and not made of hard metal or glass. If they were they would have bright highlights on them.

The overall look of the dress, combined with the antique jewelry and hairstyle, gives this portrait an accurate impression of days gone by.

Although this is more of a character study, as opposed to a fashion illustration, a lot can be learned by studying the fabric and the way the realistic drawing technique has captured it. Plaid is one of the hardest patterns to draw, and here it is done beautifully. Also, the patent leather shoe has been drawn convincingly—look at the shine.

Artist: Debbie Cichon

◄ This old-fashioned costume gives this drawing an antique feeling. The realistic technique captures all the small details of the dress.

Artist: Debbie Cichon

CONCLUSION

Every time I write a book, I end up frustrated because there is always so much more that I want to say and illustrate. I suppose it's the teacher in me wanting to give you as much information as possible. I remember submitting my first book. It was a mere 300 or so pages. Imagine my distress when I had to cut it down to 144!

So, here we go again, another book, and the author just scratching the surface of what she wants to say. The message here is: You can never know it all; there is always so much more you can learn. I have taken you part of the way. The rest is up to you; just as it was up to me many years ago.

You can learn anything you want through persistence and practice. And more practice. And repetition. And more practice. I think you get the picture. My suggestion to you is to approach fashion illustration the way I did when I was teaching myself. Draw everything you can get your hands on. Gather up fashion magazines and draw as much as you can. Don't give up and, especially, don't quit if something doesn't turn out quite right. Not all drawings are meant to be suitable for framing. They are practice work and all part of the great learning experience!

I wish all of you, who are trying so hard to hone your artistic abilities, my heartfelt wish for success. I know of nothing more rewarding than producing a quality piece of artwork that people admire. As an instructor, my greatest reward is seeing you succeed through my examples.

I know that, if you want it bad enough, you will succeed. I thank you very much for allowing me to be a part of your journey and hope I will be for a long, long time.

Sincerely,
Lee Hammond

A SPECIAL THANKS

I want to extend a special thank you to Kayce, my model for this book. Thank you for allowing me to use your beautiful image. I wish you huge success in your modeling career. I am glad I was able to participate in it in some small way.

Also, I want to thank her mother and my friend, Robin Riley, for helping me obtain the photographs, and for encouraging me to get the book done through everything else!

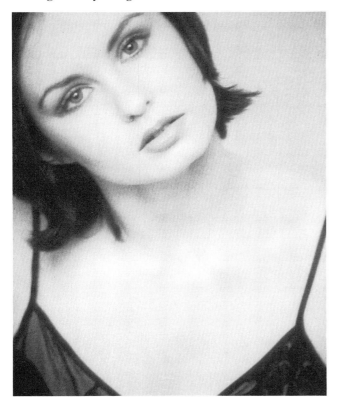

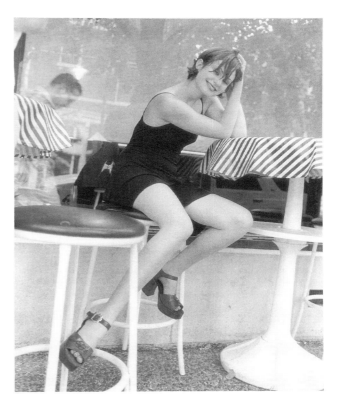

INDEX